CW00960198

POPULAR SKULLTURE

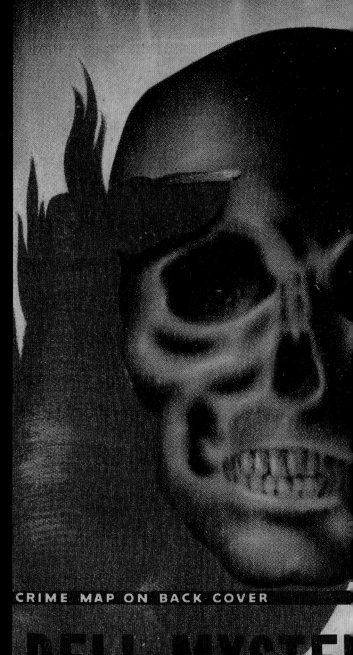

POPULAR SKULLTURE

CRIME MAP ON BACK COVER

DELL MYSTE

THE SKULL MOTIF IN PULPS, PAPERBACKS, AND COMICS

MONTE BEAUCHAMP

INTRODUCTION
STEVEN HELLER

PUBLISHER
MIKE RICHARDSON

KITCHEN SINK BOOKS
AN IMPRINT OF *DARK HORSE COMICS*
MILWAUKIE, OREGON ■ AMHERST, MASSACHUSETTS

EDITED AND DESIGNED BY:
Monte Beauchamp
Front cover typography by Lou Brooks.

FOR THEIR ENTHUSIASTIC SUPPORT OF THIS BOOK, THANK YOU:
Denis Kitchen, John Lind, and Mike Richardson

FOR HIS ENLIGHTENING INTRODUCTION, THANK YOU:
Steven Heller

FOR EDITORIAL SUPPORT, THANK YOU:
Brenda Beyers

FOR THEIR INVALUABLE RESEARCH, THANK YOU:
Daniel Zimmer, David Saunders, Dave Smith, and Piet Schreuders

AND FOR HER UNDYING SUPPORT, THANK YOU:
Rebecca Ann Hall

FOR THEIR EXQUISITE COVER SCANS, THANK YOU:
Todd Hignite, Heritage Auctions/HA.com;
Lara, Corey, and Heidi/Between the Covers Rare Books;
Charlie Johnson/Museum of the Odd; Gary Dolgoff/gdcomics.com;
Bruce Black/bookscans.com; Howard Prouty/readinkbooks.com;
Dave Smith/fantasyillustrated.net; David Alexander/dtacollectibles.com;
Yesterday's Gallery, ABAA/yesterdaysgallery.com; Steve Lawson;
Joe and Scott Edwards/Departed Paper; Tom at Monroe Stahr Books;
John W. Knott/jwkbooks.com; Lloyd Currey/lw.currey.com;
Steve Lewis, Dr. Michael J. Vassallo, Bruce Brenner,
Sarah Espinoza, and Kevin Kinley.
Scans for pages 26, 27, 32, 35, 40, 45, 50-52, 63, 69, 71, 74-76, 87,
92, 96, 98-101, 106, 109, 118-121, 127, 128, 132-134, 138, 140-142, 146, 164,
169, and 172 courtesy: Heritage Auctions/HA.com

Printed in China

1 3 5 7 9 10 8 6 4 2
First Printing: November 2014
ISBN 978-1-61655-561-0

Published by Kitchen Sink Books
An imprint of Dark Horse Comics
10956 SE Main St,
Milwaukie, Oregon 97222

CONTENTS

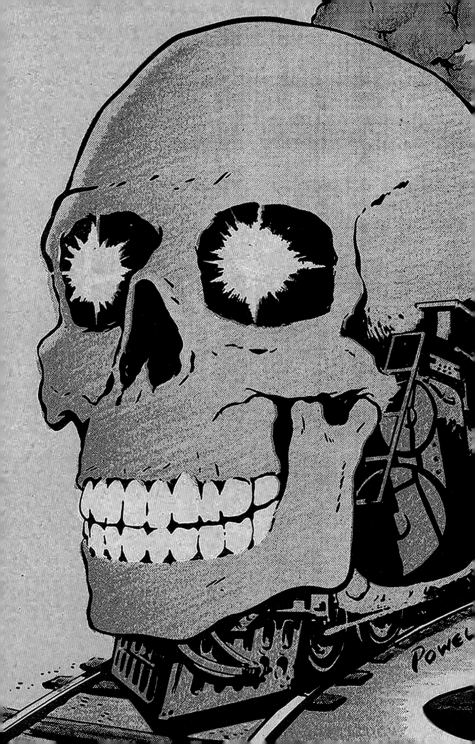

ALAS, POOR YORICK: THE SKULL AS POP CULTURE

STEVEN HELLER

Every human being is born with at least one. Throughout the world, countless numbers of them have been preserved for millennia in catacombs. Representing many things to the living, it is *the* symbol of mortality's inevitable conclusion, replete with ghoulish connotations galore. Yet it can be comic, satiric, and parodic too—albeit darkly. We know it as an emblem of ironfisted authority, populist rebellion, and criminal action, and these days it is a hip fashion accessory. In Old Norse it is called "skalli," meaning bald. However, if you, the reader, happen to have an extra-thick one and have not yet figured out what *it* is, or they are, think about the skeletal part of our human anatomy that is the armature for facial characteristics and the helmet that protects the brain from physical trauma.

Yes, I refer to the common skull, which in addition to its physiognomic importance, is the most ubiquitous graphic representation ever devised in any form and for every medium.

The skull is such a cliché that its ubiquitous display should no longer shock us. It should be ostensibly invisible to the mind's eye it covers. Yet it cannot and will not be trivialized or ignored. The common skull is never benign. It manifests power. It is shorthand for BEWARE, CAUTION, DO NOT. It signals OBLIVION. It conjures EVIL. As the emblem of Hitler's SS, the death head is as ferocious as it is fearsome. As a warning sign or poison label it is universally comprehensible. And herein lies the paradox: although the death head dates back as a military insignia in Europe centuries before the SS, in the Nazi context, the men and women who wore it were torturers and murderers. The warning signs using skulls, conversely, have saved countless lives. Two sides of the same skull.

The skull is both lethal and benign—banal and curiously beneficial as well. What science knows about the history and evolution of the human race is derived

in part from the study of skulls and bones. But there's more to skull than meets the eye socket. It is a theatrical prop used to evoke every emotion. In William Shakespeare's *Hamlet*, when the Danish prince issues this monologue over the reclaimed skull of his friend Yorick, he launches the most timeworn image of man's relationship to the skull: "Alas, poor Yorick! I knew him, Horatio; a fellow of infinite jest, of most excellent fancy; he hath borne me on his back a thousand times; and now, how abhorred in my imagination it is! My gorge rims at it. Here hung those lips that I have kissed I know not how oft. Where be your gibes now? Your gambols? Your songs? Your flashes of merriment, that were wont to set the table on a roar?"

As many times as this famous scene has been played over 400 years, the skull has had infinitely more roles in pop culture on paperbacks, pulps, magazines, film posters, comics, and more. There was a time—or so it seemed—when publishers would not allow a murder mystery off the press if a skull was not prominent on the cover or jacket. The challenge for the artists and designers has long been to repurpose the cliché in novel ways. For *Malice in Wonderland* (page 164), the illustrator cleverly created a visual pun, making skulls into coconuts. For *Holiday Homicide* (page 131), the impressionistic rendering of a skull with a top hat adds levity to the dark side.

Levity notwithstanding, skulls are a kind of delicious kitsch. On their own or as a complement to a big idea, they provide the eye with necessary cues that inform and entertain. Skulls are a universal symbol, yet they are not an all-purpose one. As versatile as they are, skulls should be avoided when telegraphing joy, happiness and goodness, births, weddings, and birthday announcements. But when serving up mystery, murder, horror, and the mortal coil, a good old skull is hard to beat.

PREFACE:
THE BONES OF THE BOOK

MONTE BEAUCHAMP

In the summer of 2007, I began assembling an array of fetching examples for a catalog of human skull iconography. A handshake agreement at Chicago's Green Mill jazz club between an executive editor for an esteemed imprint and myself cemented the deal.

The book was to run the gamut, from sixteenth-century *memento mori* ("remember that you must die") to seventeenth-century Dutch vanitas still-life paintings; from Posada's Mexican broadside engravings to World War II propaganda leaflets and posters; from century-old metamorphic penny postcards to comic books, paperbacks, and pulp magazines. Prime imagery by Dali, Warhol, and Jean-Michel Basquiat were among the examples slated for inclusion.

A month later, America's eight-trillion-dollar housing bubble burst. The monetary meltdown that followed nearly brought down the world's financial system. In the midst of the global pandemonium, our country's largest trade publishers learned a cold, harsh truth: the old adage that a book is "recession-proof" no longer proved to be the case. Empowered by computers, iPads, and other such techno-gadgets, people sought out cheap entertainment elsewhere.

Scores of publishers announced layoffs, implemented salary freezes, and fired key department heads. As independent bookstores dramatically reduced orders, established chains struggled to keep their doors open. Though Barnes & Noble is still with us, Borders failed to survive. Imprints put a halt on the acquisition of new books—including this one.

Patiently awaiting the day that my book would be re-green-lighted, I further excavated the cultural remains. One vein that proved abundantly fruitful comprised three categories of publications—comic books, paperbacks, and pulp magazines. Those that sported particularly arresting covers were born out of the

Great Depression of the 1930s, continued through the 1940s, and then, sometime during the mid-1950s, seemingly came to an abrupt end.

Intrigued and perplexed, I delved further (uncovering a striking array of stylized, evocative hardcover mystery book jackets along the way).

By the third year of the Great Depression, though the economy had hit rock bottom, New York City remained a thriving epicenter of the publishing world, employing all levels of illustrators. There were cartoonists, comic strip and caricature artists . . . fashion, pinup, and women's magazine artists . . . crime, mystery, and adventure mag artists . . . children's book, movie poster, and editorial artists. The list could go on ad infinitum.

America's demoralized people flocked to the newsstands in search of comfort, diversion—and cheap thrills. Reading enabled them to escape the horrors of everyday life: the hunger . . . the poverty . . . the unrelenting despair

Magazines fell into one of two categories: those printed on coated paper, which paid handsomely (the "slicks," such as *The Saturday Evening Post* and *Collier's*), and those printed on coarse pulpwood paper, which paid poorly (the "pulps," such as *Weird Tales* and *Spicy Detective Stories*).

Breaking into the slicks remained a pipe dream for illustrators who toiled away for the pulps, honing their craft . . . dreaming of the day they would emerge as the next Norman Rockwell. Because of the medium's low-culture status, artists often worked anonymously, reserving their name for when they graduated to the slicks. For most, that moment would never come.

As the bleak, dark decade came to a close, two new publishing venues for illustrators arose—comics and paperback books. Both mediums struck a vibrant chord with down-on-its-luck America, generating untold millions in revenue. Punch-drunk with success, editors pushed the pedal to the floor. As the publications grew more unbridled, the moral crusaders appeared.

In a 1947 issue of *New Republic*, John Mason Brown, drama critic for the *Saturday Review of Literature*, characterized comic books as "marijuana of the nursery." Pulp magazines had also experienced similar media attacks.

In 1952, a special committee of the House of Representatives, chaired by Arkansas Congressman Ezekiel C. Gathings, targeted the paperback industry. "Pocket-sized books," the committee charged, "which originally started out as cheap reprints of standard works, have largely degenerated into media for the dissemination of artful appeals to sensuality, immorality, filth, perversion, and degeneracy." Though legislation against the industry wasn't passed, rattled publishers dialed down the content.

Because of their high-culture literary status, hardcover books were placed on a pedestal, and seldom came under attack.

Sometime during the 1940s, Harlem psychiatrist Fredric Wertham became obsessed with comic books. He carried out research in clinics, schools, and in private practice, and came away convinced that comic book reading was morally and psychologically endangering the youth of the nation.

Wertham began lambasting the low-budget periodicals whenever he could. In an article in *Collier's* magazine titled "Horror in the Nursery," he claimed that "comic book reading was a distinct influencing factor in the case of every single delinquent or disturbed child we studied." Crime comics inspired boys to rob and to kill the good doctor declared, whereas love comics created feelings of inferiority in adolescent girls because their bosoms were not yet full.

Seduction of the Innocent, Wertham's incendiary indictment of the comic book industry, arrived in bookstores in the spring of '54. That same season, a televised Senate Subcommittee Hearing into comic books and their relationship to juvenile delinquency aired.

Amid public comic book burnings, states passing laws restricting their sales, and mothers boycotting the nation's newsstands, frantic publishers formed the Comics Magazine Association of America—implementing an inflexible regulatory code. Dozens of titles were axed; innovative imprints went under; and hundreds of industry professionals found themselves out of work.

The mass hysteria over comic books, inspired by a lone psychiatrist from Harlem, decimated an immensely popular—and original—American art form.

.

On March 8, 2013, over 350 people flocked to the opening night reception of the career retrospective on Harvey Kurtzman, the founding editor and creator of an American institution—*MAD*. The ambitious New York exhibition was curated by cartoon historian Denis Kitchen and myself for the Society of Illustrators.

An hour into the festive event, Denis sidled over and announced that he and designer John Lind had entered into a joint publishing venture with Dark Horse Comics to start a new imprint. I began reminiscing about my floundering skull book and its sumptuous cache of paperback, pulp, hardback, and comic book covers that might never get featured. A stand-alone volume of pop culture artifacts of their caliber would make for a compelling collection.

Late in the evening, in the din of the Society's upstairs bar, as I pitched the idea to Denis, a title rolled off my tongue—*Popular Skullture*. By the next round of drinks, the deal was sealed.

A PULP PRIMER:
THE '30s, '40s, and '50s
MONTE BEAUCHAMP

PULP MAGAZINES

Not only was Benjamin Franklin a founding father of the United States, he was also an accomplished printer and fathered the nation's first magazine.

As Franklin was assembling the inaugural issue of *The General Magazine*, along came two snakes in the grass—editor John Webb and printer Andrew Bradford, who rushed out a knockoff before him.

Colonial America embraced Franklin's creation, and with each passing decade, more and more titles made their way into the hands of the middle class.

In autumn of 1882, Frank A. Munsey arrived in the city of New York, intent on building a publishing empire. Backed by printer E. G. Rideout, that winter he launched *The Golden Argosy*. Although the publication's masthead trumpeted the weekly was: "Freighted with Treasure for Boys and Girls," the series lacked luster, failing to establish a flourishing readership. Six years later, *The Golden Argosy* became *The Argosy*.

At the start of the next decade, amid stagnant sales and a mounting pile of unpaid bills, Munsey remained wedded to the idea of publishing. Inspired by Horatio Alger's rags-to-riches fiction stories, the impoverished businessman forged onward.

In January 1896, Munsey revamped his floundering series into an all-fiction, monthly publication aimed at America's working class. On the front cover of the cheaply priced—and printed—pulpwood periodical, the struggling publisher proudly proclaimed, "With this issue *The Argosy* throws off its knickerbockers and joins the adult ranks."

Long perturbed that major distributors monopolized the magazine industry, Munsey struck back—peddling his publication directly to newsstands and dealers, and making a much bigger profit for himself.

The results? Astounding. Within just two issues, sales spiked upward, from 40,000 copies to 80,000. Eleven years later, Munsey's mag boasted a circulation of half a million!

The Argosy spawned rivals, popularizing a new breed of periodical: the pulps, aptly named for the cheap, porous paper their interiors were printed on.

The burgeoning medium thrived, prospered, and expanded. From its prodigious stable of genres, one in particular would significantly shape the twentieth century—scientific-fiction, later dubbed science fiction.

Iconic fictional heroes were also birthed in the pulps: Tarzan, Zorro, and Buck Rogers became national treasures.

With an unyielding flow of new titles spilling onto the racks, editors pushed cover illustrators to crank up the content to attract newsstand passersby. The more lurid, the more crass, the more vibrantly colored, the better!

Dime Mystery Magazine (1933), *Terror Tales* (1934), and *Horror Stories* (1935) fostered a new style of pulp known as "shudder" pulps. Their amoral, exploitive covers and content created quite an emotional stir. New York City's mayor Fiorello La Guardia vowed to crush those who published the tawdry periodicals. "Clean up your act," the five-foot, two-inch firebrand warned them, "or get outta town!!!" Parents, horrified to learn their children had been consuming such trash, took a very dim view of the pulps. Yet despite a mounting public disdain for them, the medium continued to flourish.

Just how popular were the pulps? In 1926, the Audit Bureau of Circulation cited nearly 30 titles; by 1938, nearly 100 additional titles had been added. That same year, a new periodical employing both word and pictures arrived on the block.

COMICS

In 1934, decorated military war hero and pulp magazine writer Major Malcolm Wheeler-Nicholson noticed a new breed of periodical coming into vogue: reprint anthologies of newspaper comic strips. Inspired, the New Yorker threw his hat into the ring and formed National Allied Publications.

The company's flagship title, *New Fun: the Big Comic Magazine*, made its newsstand debut in early 1935, but made only a tepid splash. Both readers and distributors alike didn't know quite what to make of the tabloid's original content, created by nobodies.

Two years later, mired in debt and spiraling toward bankruptcy, the destitute comic book publisher reached out to its distributor, the Independent News Company. Though the major had heard the rumors, about how head salesman

Harry Donenfeld—also the publisher of a lewd line of under-the-counter pulp magazines—held underworld ties, he partnered with Independent.

In the midst of assembling *Action Comics* #1, the major was suddenly ousted. Continuous financial problems had caused the alliance to sour.

Released in 1938, the inaugural issue of the anthology was a virtual sellout, as were numbers two, three, and four. Perplexed as to why sales were soaring, Donenfeld grilled newsstand vendors—all of whom bellowed, "Supeman!"

America's first superhero was the brainchild of writer Jerry Siegel and artist Joe Shuster, two devout science fiction fans from Cleveland, Ohio. In January 1939, Superman was awarded his own daily newspaper comic strip and that summer, a self-titled series. There was Superman *this*, Superman *that*, and publishing rivals who wanted in on the act.

Soon after the debut of Superman, another costumed crusader arrived on the scene—the Batman, followed by Wonder Man. There was Amazing-Man, the Ultra-Man, Doll Man . . . Hawkman, Master Man, Dynamic Man . . . Hourman, Bulletman, Skyman . . . Airman, Minute-Man, Starman . . . Vapo-Man, the Hangman, and Plastic Man . . . Aquaman, V-Man, Pyroman . . . and throngs more "men-of-steel" creations bounding onto newsstands, crowding out the pulps.

PAPERBACK BOOKS

British publishing houses struggled to stay afloat throughout the Great Depression. Such was the case with Allen Lane, who began an apprenticeship at his uncle's London-based imprint, the Bodley Head, in 1919.

The sixteen-year-old started as an office boy and worked his way up. With his uncle's passing in 1925, Lane became director of the firm. Five years later he was appointed chairman.

While awaiting a train back to London after a weekend visit with mystery novelist Agatha Christie, Lane began perusing the station's bookstall for something to read. Appalled to find nothing but rubbish, he struck on the idea of producing a line of intelligent pocket-sized paperbacks, modestly priced.

Bodley Head board members scoffed at the idea. Softcover reprint editions of quality hardcovers—at one sixteenth the price—they argued would ruin the book trade. Lane, believing there was a vast untapped market for popular fiction and nonfiction titles, produced and priced cheaply, stood his ground. Halfheartedly, the board acquiesced.

As staff members bandied about names for the new imprint, secretary Joan Coles hit on a keeper—Penguin Books. Twenty-one-year-old Edward Young, an

office junior, went to the London zoo to sketch the aquatic bird, from which he developed the company's logo.

From the outset, Lane demanded a classy cover look for Penquin, no pictures of "bosoms or bottoms," he insisted. Based on a three-tier horizontal grid, Young branded the line with a vivid yet sparse design—a thick band of color bled off the top and bottom of each cover, with a wedge of white in between, showcasing the title and author's name. Each genre was coded by color: Green bands designated crime; orange, fiction; and blue, non-fiction.

In July 1935, Lane launched ten titles, each with a print run of 20,000 copies. Marketed beyond the traditional distribution channel—bookstalls and book-shops—reorders poured in.

In a letter to Lane from Helen Ashton dated May 13, 1936, the author noted, "I am very proud to be a Penguin and felt that real success had come when I found myself selling at Woolworths!"

Eighteen months after the dawn of Penguin Books, the company's backlist numbered over 100 titles.

Riveted by the British imprint's success, American Robert deGraff, backed by New York City publishing powerhouse Simon & Schuster, entered the fray. Coining the name Pocket Books, he parroted the Penguin model. DeGraff, how-ever, eschewed the company's staid, templated cover look in favor of one more illustrative, colorful, and typographically diverse.

After successfully test-marketing a low-run edition of Pearl S. Buck's *The Good Earth*, in spring 1939 deGraff issued ten titles in much larger quantities and distributed them throughout New York City. Whereas the hardback version of James Hilton's *Lost Horizon* retailed for two dollars, Pocket Books' petite softcover cost only a quarter. In an ad placed by deGraff in *Publishers Weekly*, he trumpeted that 107,000 Pocket Books had been sold within three weeks of their initial release.

Though sales looked promising, deGraff still faced a major hurdle. Due to his product's slim profit margin, bookstores had little interest in handling the Pocket Book line. Undeterred, he then struck a deal with an outlet that would—the country's multi-tentacled magazine distribution network.

The price, format, and colorful covers of the experimental editions captured the heart of the mass market. Sales exploded, earning deGraff millions of dollars. And just as he had done to Penguin, others parroted his Pocket Book model.

Right: *The Death Syndicate*, artist unknown, hardcover, Ives Washburn, 1938

THE DEATH SYNDICATE

No. 1933X

PASSPO

JUDSON P. PHILIPS

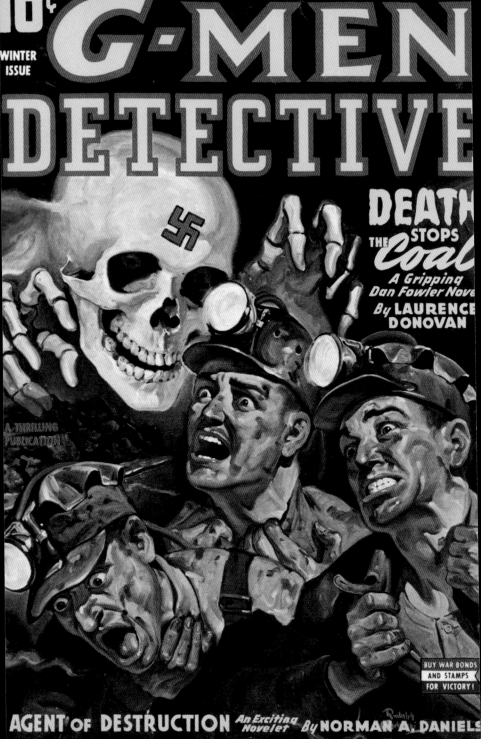

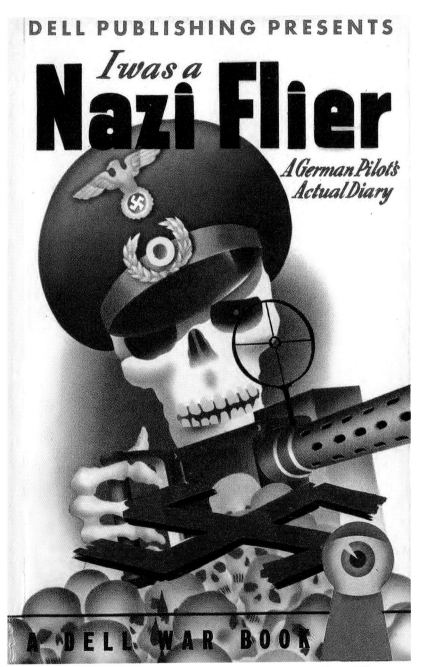

DELL PUBLISHING PRESENTS

I was a

Nazi Flier

*A German Pilot's
Actual Diary*

A DELL WAR BOOK

Left: *G-Men Detective*, pulp magazine, Rudolph Belarski, Better Publications, Winter 1944
Above: *I Was a Nazi Flyer*, paperback, Gerald Gregg, Dell Books, 1943

23

A FIEND IN NEED

BY MILTON K. OZAKI

A NEW PROFESSOR CALDWELL MYSTERY, BY THE AUTHOR OF THE CUCKOO CLOCK

Above: *A Fiend in Need*, hardcover, artist unknown, Ziff-Davis, 1947
Right: *Fourth Mystery Companion*, hardcover, artist unknown, Lantern Press, 1946

FOURTH MYSTERY COMPANION

Ellery Queen

Dashiell Hammett Louis Paul Vincent Starrett

William Irish Frank Owen Sax Rohmer

Freeman Wills Crofts Cornell Woolrich

Walter C. Brown Richard Kent

William MacHarg Hugh Pentecost

Leslie Charteris Mignon Eberhart

Frederick Skerry

Elisabeth Sanxay Holding George Harmon Cox

Q. Patrick

EDITED BY A. L. FURMAN

COB

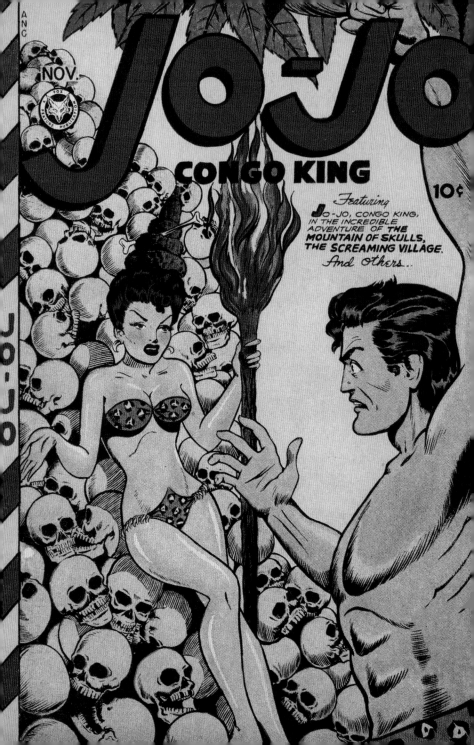

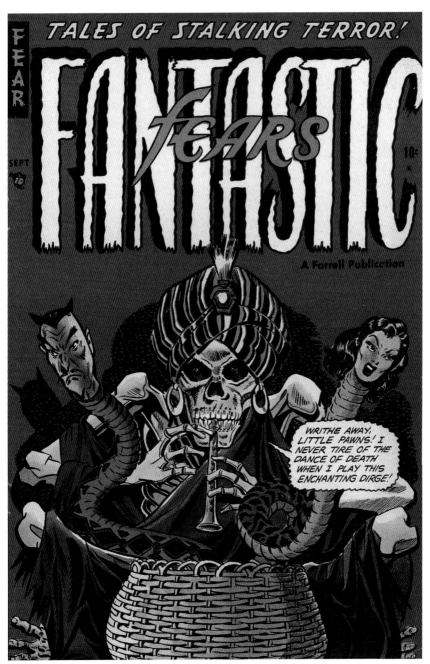

Left: *Jo-Jo Congo King* #8, comic book, Jack Kamen, Fox Features Syndicate, 1947
Above: *Fantastic Fears* #3, comic book, artist unknown, Farrell, 1953

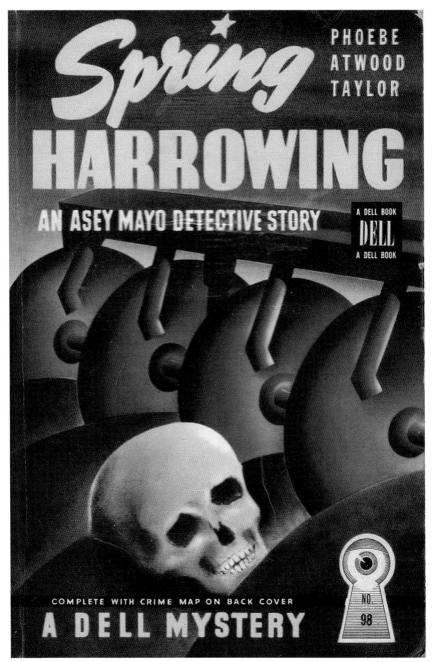

PHOEBE
ATWOOD
TAYLOR

Spring

HARROWING

AN ASEY MAYO DETECTIVE STORY

A DELL BOOK
DELL
A DELL BOOK

COMPLETE WITH CRIME MAP ON BACK COVER

A DELL MYSTERY

NO. 98

Above: *Spring Harrowing*, paperback, Gerald Gregg, Dell Books, 1945
Right: *The Bloody Wig Murders*, pulp digest, Norm Saunders, Select Publications, 1942

The BLOODY WIG MURDERS

A COMPLETE $2.00 NOVEL

By GEORGE BAGBY

BEST DETECTIVE NO. 4 - 25 Selection

DEATH COMES TO DINNER

ANOTHER
THATCHER FAMILY
MYSTERY BY

PETER YATES

25c FIVE STAR MYSTERY 4

Above: *Death Comes to Dinner*, pulp digest, artist unknown, Green Publishing Co., 1945

DEATH
COMES GRINNING

FIVE STAR
MYSTERY
25c

WILL
CREED

A FULL-LENGTH NOVEL — NEVER BEFORE PUBLISHED

Above: *Death Comes Grinning*, pulp digest, artist unknown, Green Publishing Co., 1946

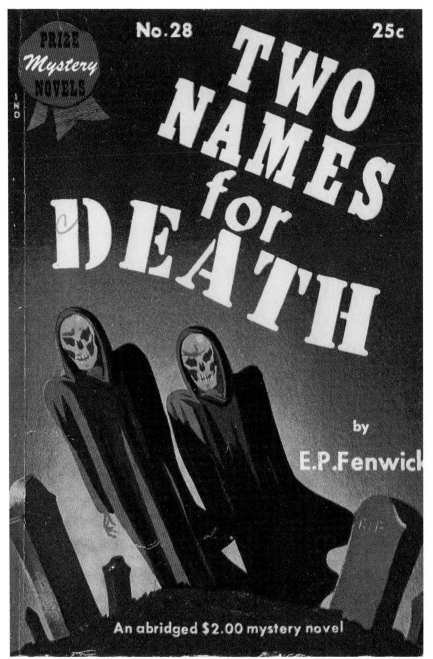

Left: *Strange Mysteries* #12, comic book, artist unknown, Superior Comics, 1953
Above: *Two Names for Death*, pulp digest, artist unknown, Crestwood Publishing, 1947

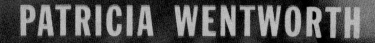

POPULAR LIBRARY

A MISS SILVER MYSTERY

131

THE CLOCK STRIKES TWELVE

PATRICIA WENTWORTH

"THE STORY MOVES SMOOTHLY THROUGHOUT."
CHICAGO TRIBUNE

Above: *The Clock Strikes Twelve*, paperback, H. Lawrence Hoffman, Popular Library, 1947

Right: *Nick Carter Magazine*, pulp magazine, Jerome Rozen, Street & Smith, 1935

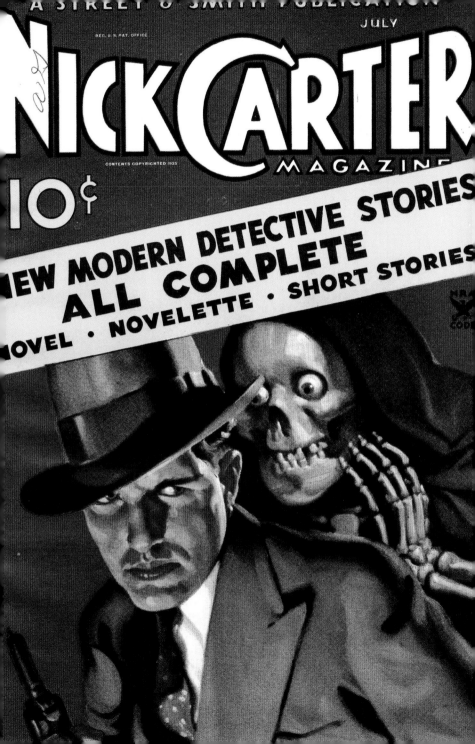

DIG ME A GRAVE

JOHN SPAIN

Death
RIDES A HOBBY

ROYCE HOWES

A candid camera, fireworks, high-heeled slippers and three amateur burglaries spelled murder to Capt. Ben Lucias.

Left: *Dig Me a Grave*, hardcover, artist unknown, E. P. Dutton, 1942
Above: *Death Rides a Hobby*, hardcover, artist unknown, Doubleday Crime Club, 1939 **37**

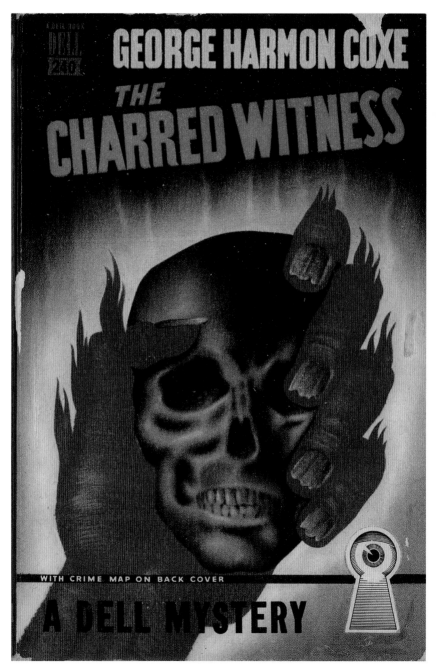

GEORGE HARMON COXE

THE
CHARRED WITNESS

WITH CRIME MAP ON BACK COVER

A DELL MYSTERY

Above: *The Charred Witness*, paperback, Gerald Gregg, Dell Books, 1948
Right: *The Crooked Circle*, pulp digest, Crestwood Publishing, 1945

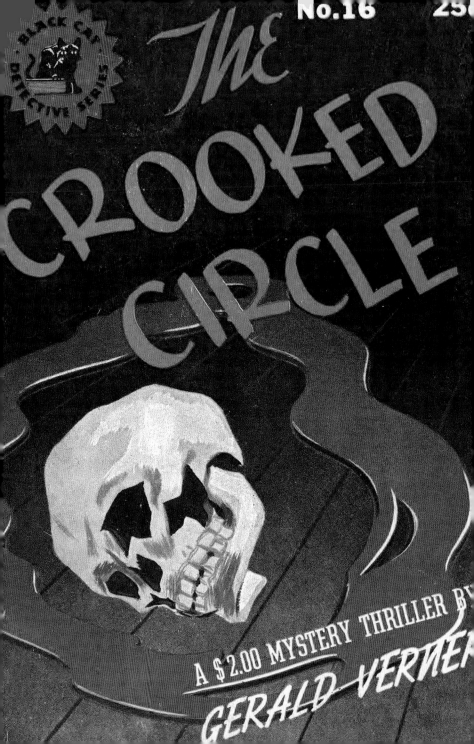

THE CROOKED CIRCLE

BLACK CAT
DETECTIVE SERIES

A $2.00 MYSTERY THRILLER BY
GERALD VERNER

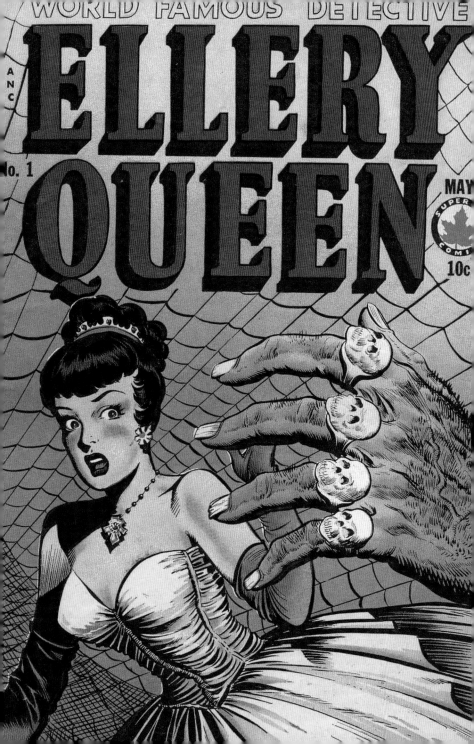

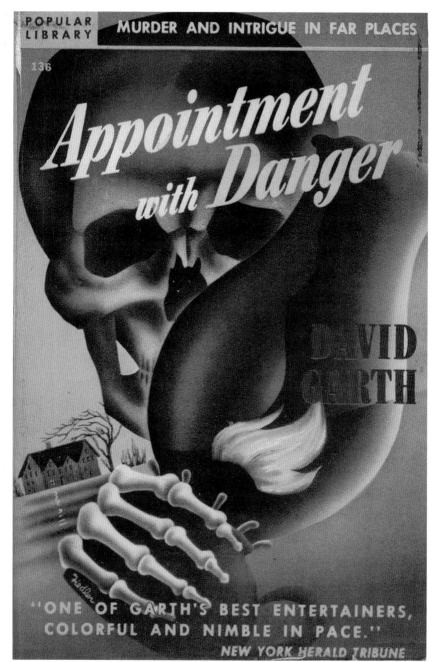

Left: *Ellery Queen* #1, comic book, Jack Kamen, Superior Comics, 1949
Above: *Appointment with Danger*, paperback, Fiedler, Popular Library, 1945

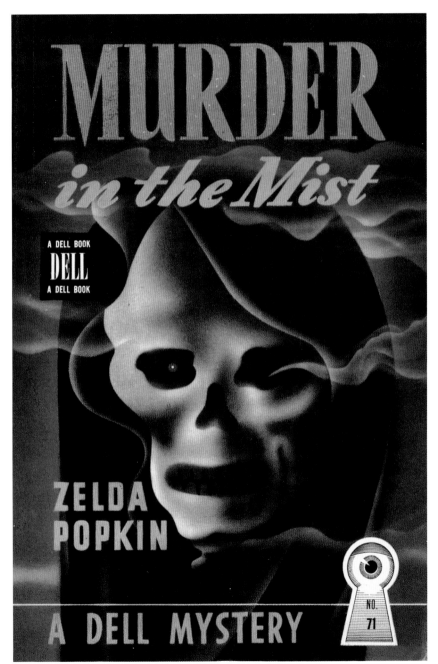

Above: *Murder in the Mist*, paperback, Gerald Gregg, Dell Books, 1945

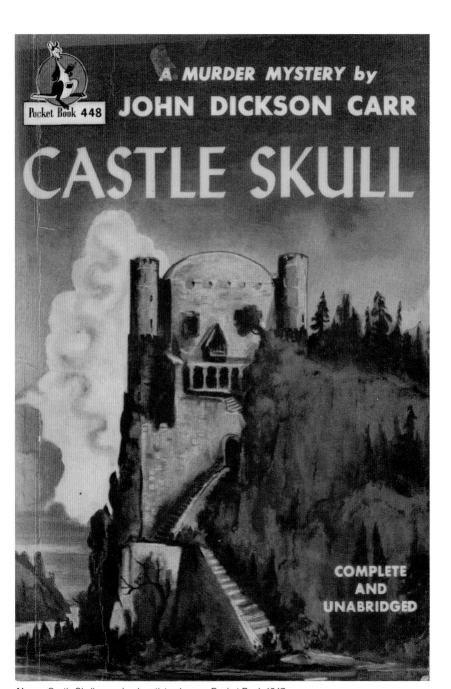

A MURDER MYSTERY by

JOHN DICKSON CARR

Pocket Book 448

CASTLE SKULL

COMPLETE
AND
UNABRIDGED

Above: *Castle Skull*, paperback, artist unknown, Pocket Book,1947

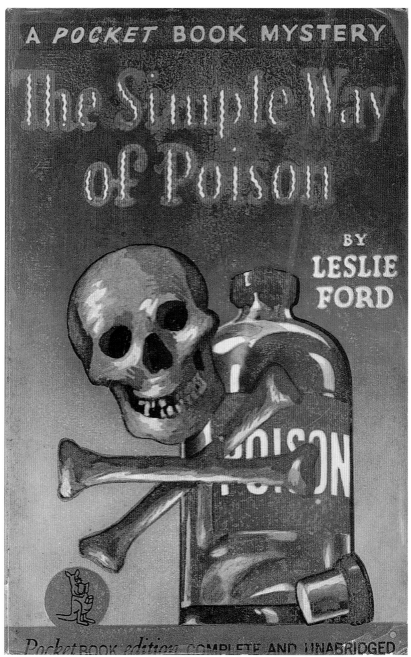

A POCKET BOOK MYSTERY

The Simple Way
of Poison

BY
LESLIE
FORD

POISON

Pocket BOOK edition COMPLETE AND UNABRIDGED

Above: *The Simple Way of Poison*, paperback, artist unknown, Pocket Book, 1941
Right: *Mysterious Traveler Comics* #1, comic book, Bob Powell, Trans World, 1948

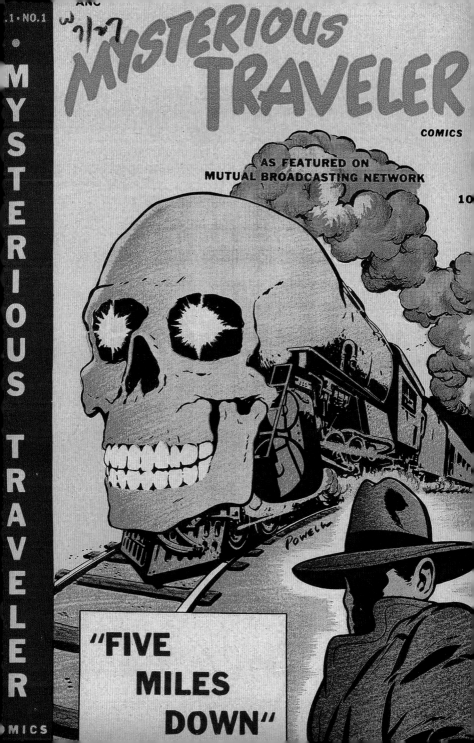

EVIDENTLY MURDERED

JAY HALL

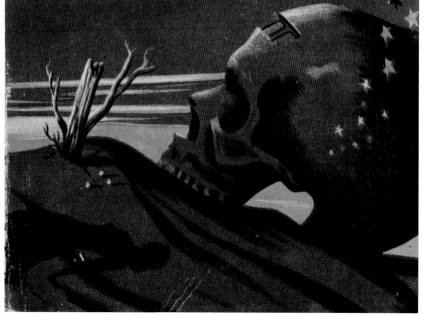

Left: *Evidently Murdered*, hardcover, artist unknown, Dorrance and Company, 1943
Above: *Lady, That's My Skull*, paperback, artist unknown, Hangman's House, 1946

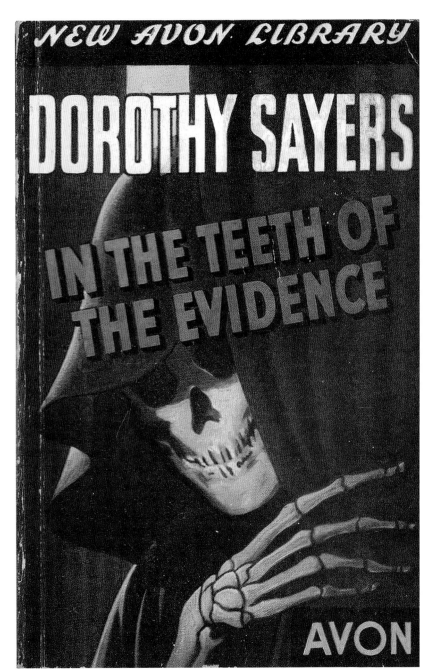

DOROTHY SAYERS

IN THE TEETH OF
THE EVIDENCE

AVON

Above: *In the Teeth of the Evidence*, paperback, artist unknown, Avon, 1943
Right: *Murder from Three Angles*, hardcover, Leonard Frank, Lee Furman, 1939

MURDER
FROM
THREE ANGLES

J. RUSSELL WARREN

TOMB
OF TERROR

.12

V.

PDC

TOMB
OF TERROR

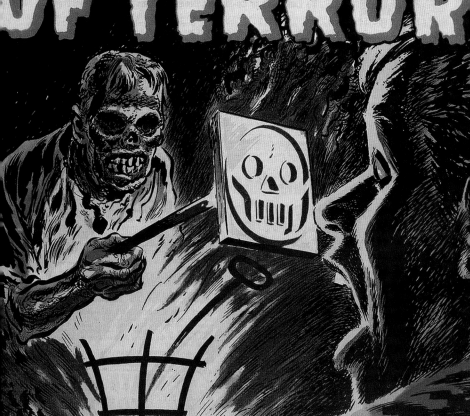

A tale of endless horror is a TALE OF CAIN

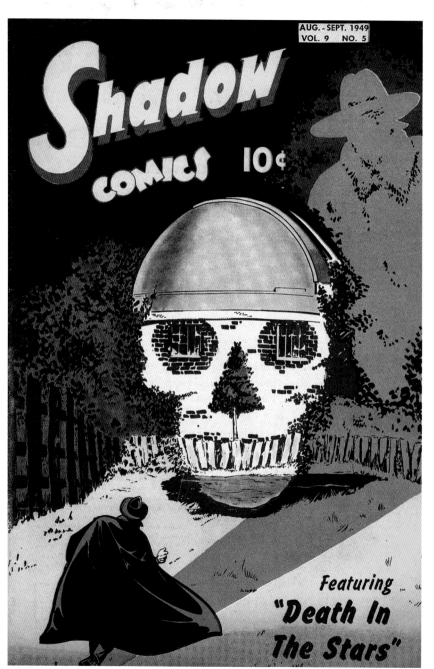

Left: *Tomb of Terror* #12, comic book, Lee Elias, Harvey, 1953
Above: *Shadow Comics* vol. 9 #5, comic book, Bob Powell, Street & Smith, 1949

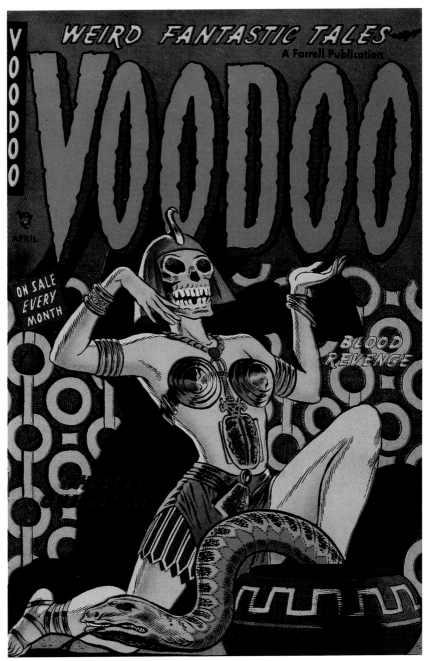

Above: *Voodoo* #8, comic book, artist unknown, Farrell, 1953
Right: *Thrilling Mystery*, pulp magazine, artist unknown, Standard, 1937

THRILLING
MYSTERY

FEB.

10¢

AVES
F THE
ANCING
ATH
Novelette of
irling Horror
JOHN
KNOX

A THRILLING
PUBLICATION

HELL'S
DARKEST
HALLS
A Novelette of
Terror's Chateau
By HUGH B. CAVE

AND MANY OTHERS

ISS OF
EATH
Weird Novelette
DALE CLARK

NO. 1 **25¢**

the ROSE PETAL MURDERS

PRIZE MYSTERY NOVELS

by **CHARLES G. GIVENS**

A FULL LENGTH $2⁰⁰ DETECTIVE THRILLER

H

Above: *The Rose Petal Murders*, pulp digest, H. Lawrence Hoffman, Crestwood Publishing, 1943

Above: *Murder in the House with Blue Eyes*, pulp digest, artist unknown, Margood Publishing, 1944

THE CROSSWORD MURDER

BY
E. R. PUNSHON

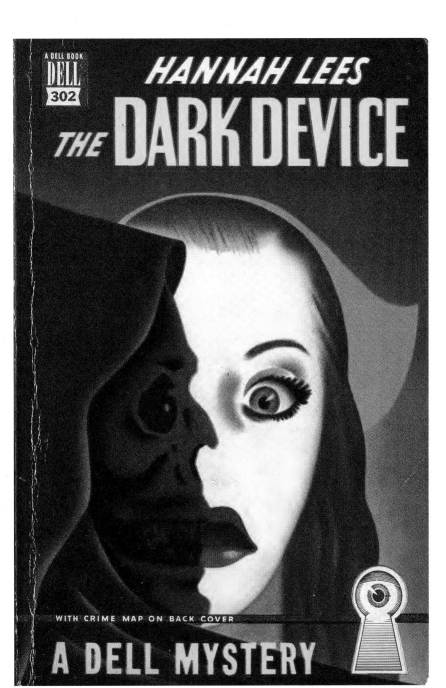

Left: *The Crossword Murder*, hardcover, artist unknown, Alfred A. Knopf, 1934
Above: *The Dark Device*, paperback, Gerald Gregg, Dell Books, 1949

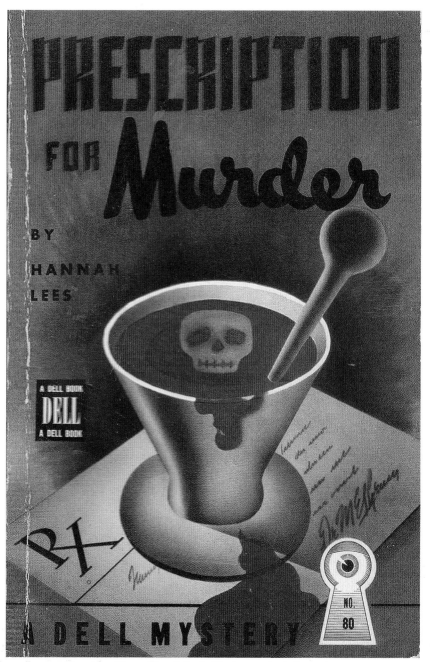

Above: *Prescription for Murder*, paperback, Gerald Gregg, Dell Books, 1945
Right: *Spring Harrowing*, hardcover, artist unknown, W. W. Norton, 1939

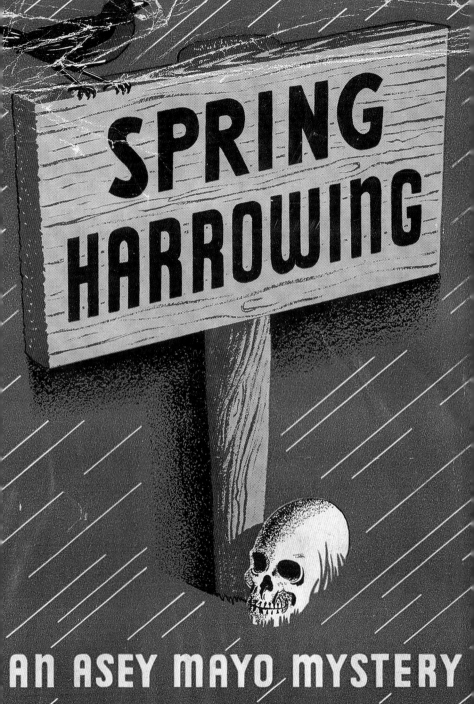

SPRING HARROWING

AN ASEY MAYO MYSTERY

PHOEBE ATWOOD TAYLOR

STRANGE

10¢

NOVEMBER

DETECTIVE

MYSTERIES

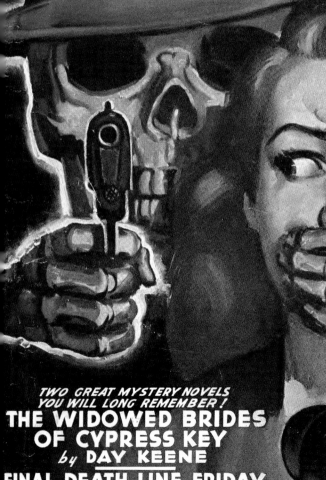

TWO GREAT MYSTERY NOVELS
YOU WILL LONG REMEMBER!

THE WIDOWED BRIDES
OF CYPRESS KEY
by DAY KEENE

FINAL DEATH LINE FRIDAY
by FRANCIS K. ALLAN
PLUS MANY OTHER BIZARRE MYSTERY TALES

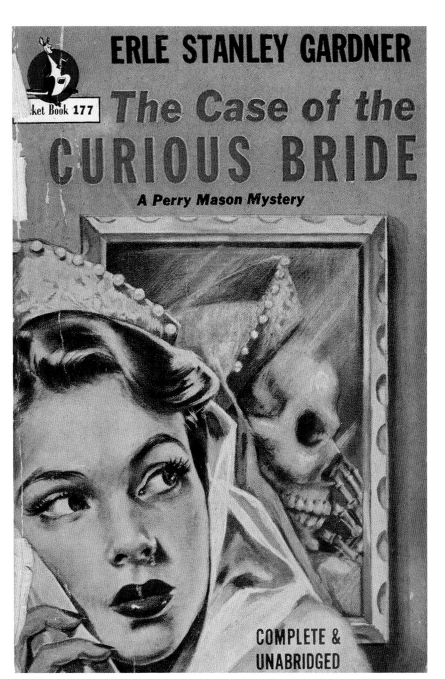

ERLE STANLEY GARDNER

ket Book **177** *The Case of the*
CURIOUS BRIDE

A Perry Mason Mystery

COMPLETE &
UNABRIDGED

Left: *Strange Detective Mysteries*, pulp magazine, Milton Luros, Popular Publications, 1942
Above: *The Case of the Curious Bride*, paperback, artist unknown, Pocket Book, 1942 **61**

108

A TASTE FOR HONEY

"A Triumph of Modern Mystery"

BY

H.F. HEARD

"A TRIUMPH OF INGENUITY"
—Boris Karloff

•

"PACKING PLENTY OF HORROR"
—N. Y. Herald Tribune

•

"WHAT DELIGHT...FOR EVERY TRUE DETECTIVE STORY LOVER"
—Christopher Morley

•

"TERRIFYING...PERFECTLY DONE"
—Vincent Starrett

Above: *A Taste for Honey*, paperback, artist unknown, Avon, 1946
Right: *Popular Detective*, pulp magazine, Walter DeMaris, Better Publications, 1939

ENC

25¢
0¢ IN CANADA

MURDER
IN THE
RADIO
DEPARTMENT

by
ALFRED EICHLER

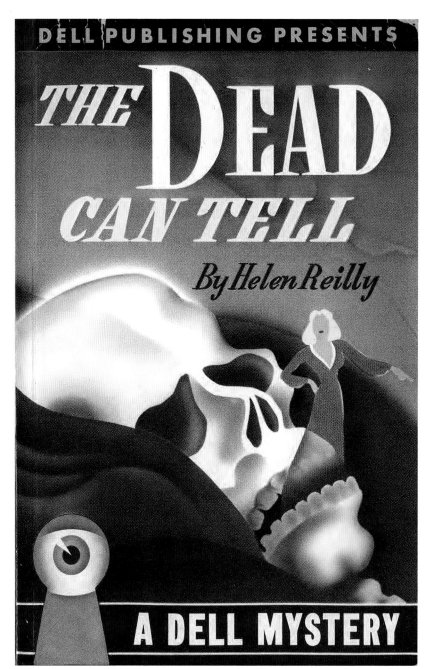

DELL PUBLISHING PRESENTS

THE DEAD *CAN TELL*

By Helen Reilly

A DELL MYSTERY

Left: *Murder in the Radio Department*, pulp digest, artist unknown, Spotlight Publishers, 1944
Above: *The Dead Can Tell*, paperback, Gerald Gregg, Dell Books, 1943

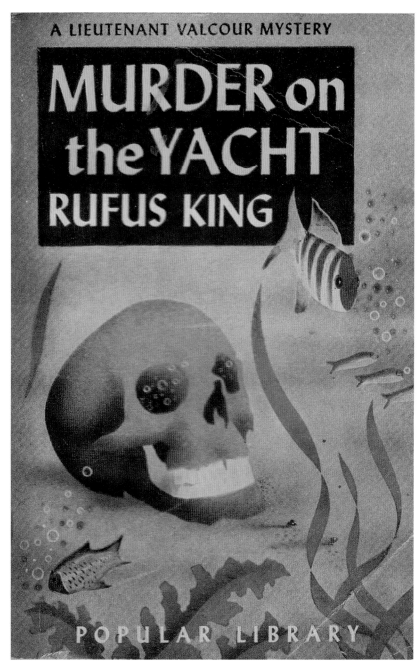

A LIEUTENANT VALCOUR MYSTERY

MURDER on the YACHT
RUFUS KING

POPULAR LIBRARY

Above: *Murder on the Yacht*, paperback, H. Lawrence Hoffman, Popular Library, 1945

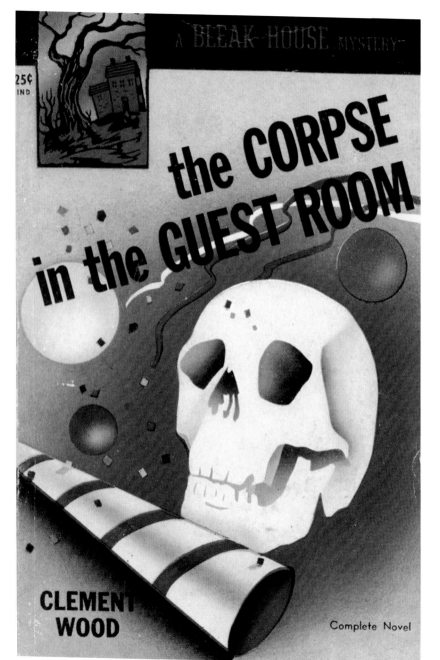

A BLEAK HOUSE MYSTERY

25¢
IND

the CORPSE
in the GUEST ROOM

CLEMENT
WOOD

Complete Novel

Above: *The Corpse in the Guest Room*, paperback, artist unknown, Parsee Publications, 1947

the red lamp

**MARY
ROBERTS
RINEHART**

A DELL BOOK
DELL
A DELL BOOK

COMPLETE WITH CRIME MAP ON BACK COVER

NO. 131

A DELL MYSTERY

Above: *The Red Lamp*, paperback, Gerald Gregg, Dell Books, 1946
Right: *The Shadow*, pulp magazine, George Rozen, Street & Smith, 1942

THE

Shadow

A STREET & SMITH PUBLICATION

10¢ **TWICE A MONTH**
JULY · 15 · 1942

DEATH ABOUT TOWN

It stalks rich and poor alike in this
smashing complete mystery novel.

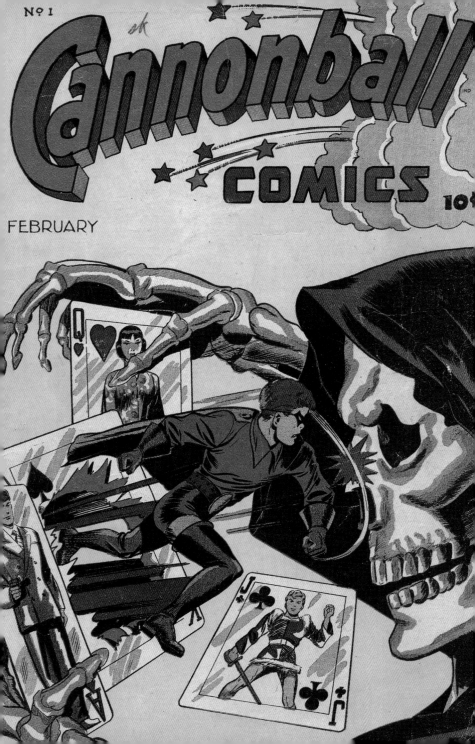

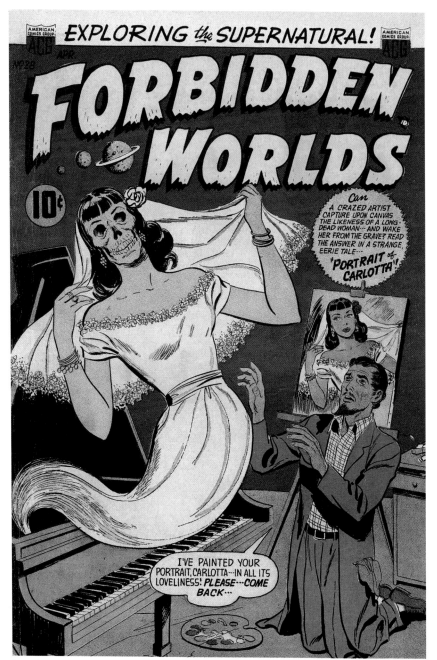

Left: *Cannonball Comics* #1, comic book, artist unknown, Rural Home, 1945
Above: *Forbidden Worlds* #28, comic book, Ken Bald, ACG, 1954

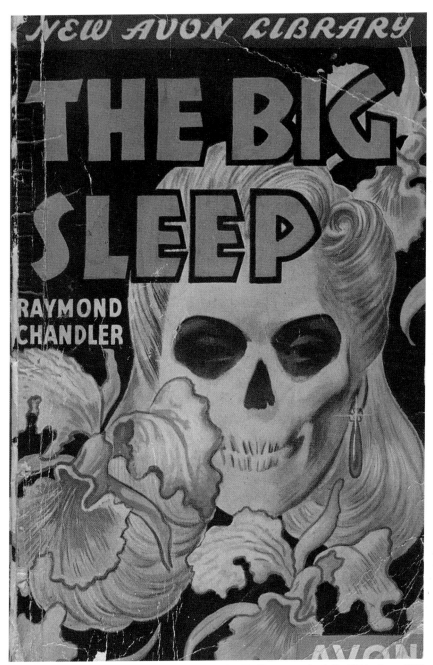

Above: *The Big Sleep*, paperback, Paul Stahr, Avon, 1944
Right: *Secret Agent "X"*, pulp magazine, J. George Janes, Ace, 1934

10¢

FEBRUARY

NRA

SECRET AGENT "X"

THE MAN OF A X THOUSAND FACES

Secret Agent
"X"
In a Sensational
BOOK-LENGTH
NOVEL
Complete in this Issue

The
TORTURE
TRUST

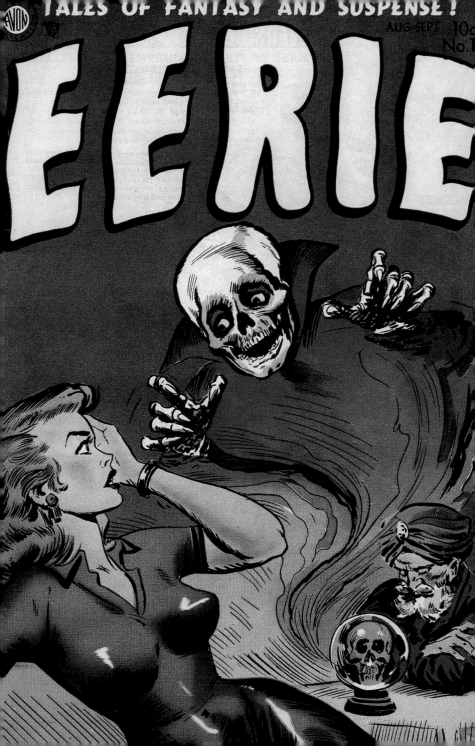

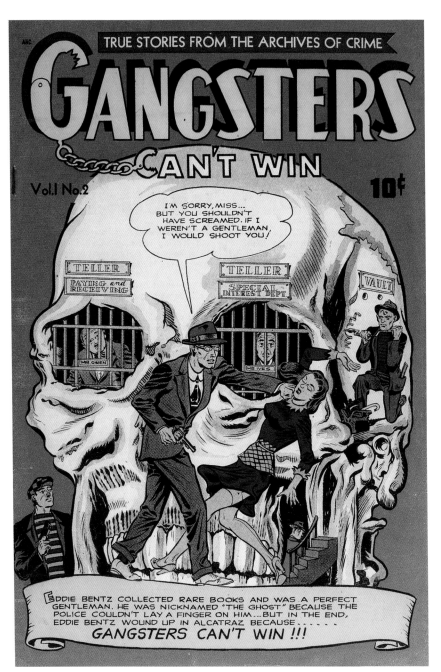

Left: *Eerie* #17, comic book, artist unknown, Avon, 1954
Above: *Gangsters Can't Win* #2, comic book, artist unknown, D. S. Publishing, 1948

AUG. 25c

Weird Tales

Paul Ernst

Seabury Quinn

L. M. Montgomery

John Scott Douglas

Frances Bragg Middleton

MEET THE SINISTER AND MYSTERIOUS
DOCTOR SATAN
THE WORLD'S WEIRDEST CRIMINAL

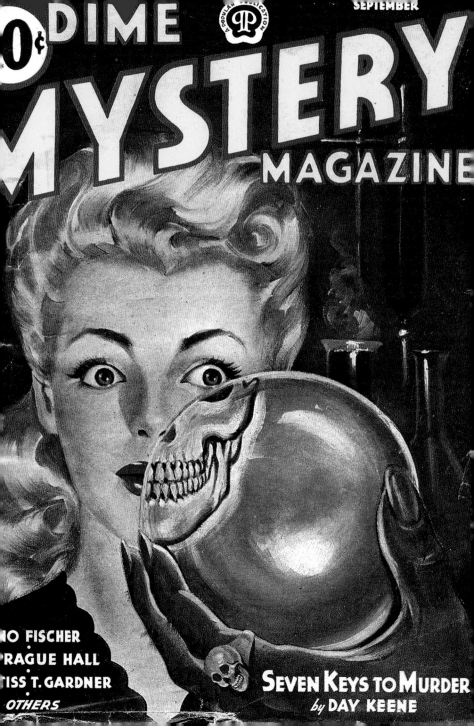

Above: *Rattle His Bones*, pulp digest, Cardwell Higgins, London Publishing, 1944

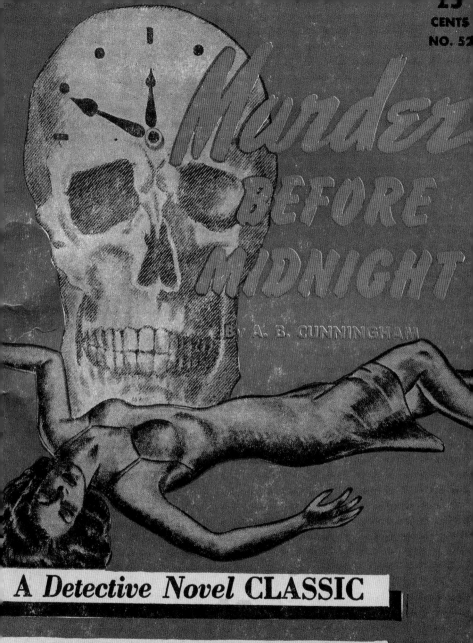

Above: *Murder Before Midnight*, pulp digest, artist unknown, Novel Selections, 1945

DEATH from A TOP HAT

CLAYTON RAWSON

In which a dead magician mystifies a
live one and THE GREAT MERLIN
almost meets his match! *Illustrated*

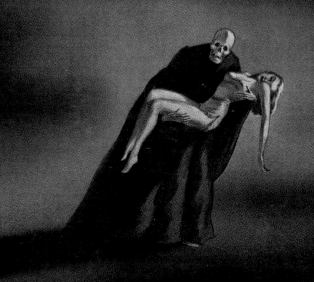

BODIES ARE WHERE YOU FIND THEM

Brett Halliday

A MICHAEL SHAYNE STORY

Left: *Death from a Top Hat*, hardcover, Clayton Rawson, G. P. Putnam, 1938
Above: *Bodies Are Where You Find Them*, hardcover, Charles Lofgren, Henry Holt and Co., 1941 **81**

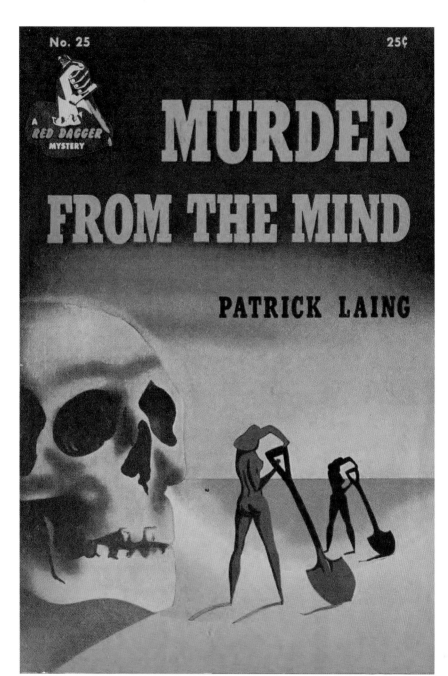

Above: *Murder from the Mind*, pulp digest, artist unknown, Dagger House, 1947
Right: *10 Story Mystery Magazine*, pulp magazine, artist unknown, Popular Publications, 1944

10 STORY MYSTERY MAGAZINE

10¢

NOVEMBER

HOMICIDE HIGHWAY

by HUGH B. CAVE

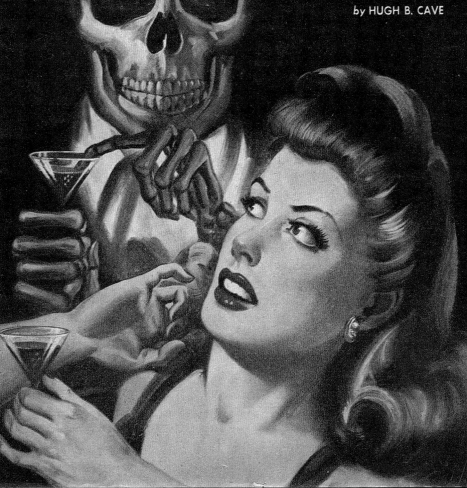

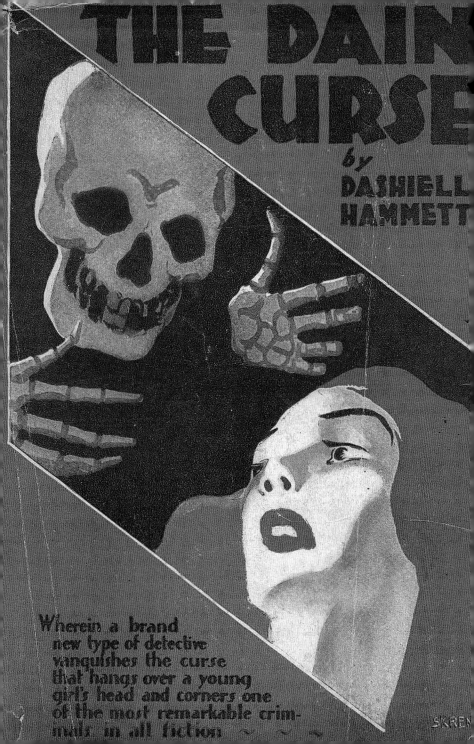

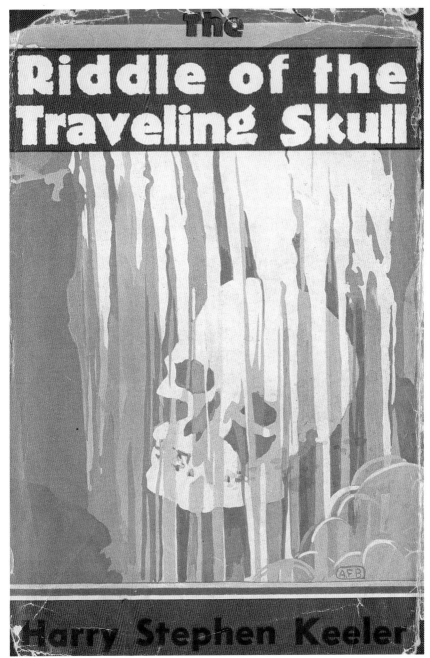

Left: *The Dain Curse*, hardcover, Skrenda, Grosset & Dunlap, 1929
Above: *The Riddle of the Traveling Skull*, hardcover, artist unknown, E. P. Dutton & Co., 1934 **85**

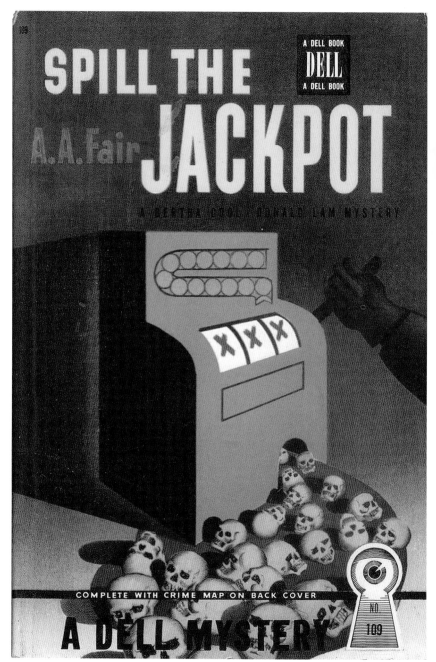

COMPLETE WITH CRIME MAP ON BACK COVER

Above: *Spill the Jackpot*, paperback, George A. Frederiksen, Dell Books, 1948
Right: *Nick Carter Magazine,* pulp magazine, Jerome Rozen, Street & Smith, 1933

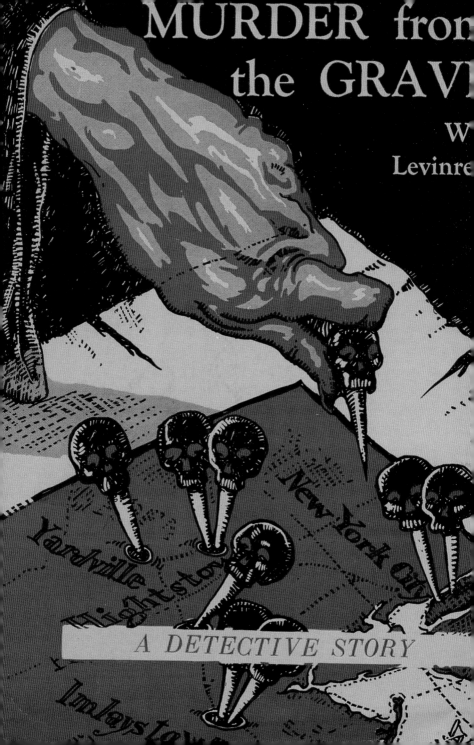

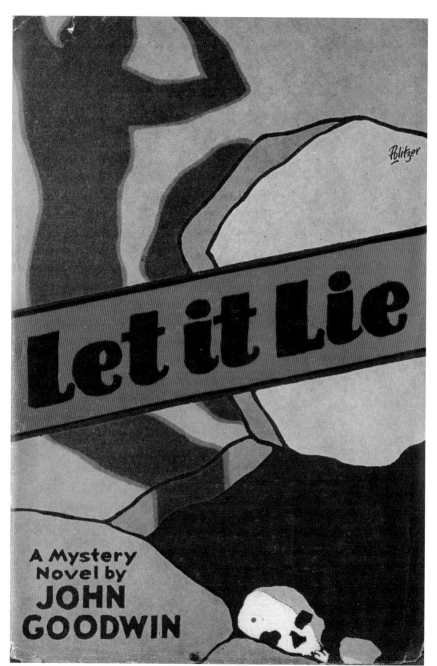

Left: *Murder from the Grave*, hardcover, artist unknown, Tudor Publishing, 1932
Above: *Let It Lie*, hardcover, Politzer, G. P. Putnam's Sons, 1929

Above: *Death Looks Down*, hardcover, artist unknown, Ziff-Davis, 1944

DELL PUBLISHING PRESENTS

DOUBLE FOR DEATH

REX STOUT

A DELL MYSTERY

Above: *Double for Death*, paperback, George A. Frederiksen, Dell Books, 1943

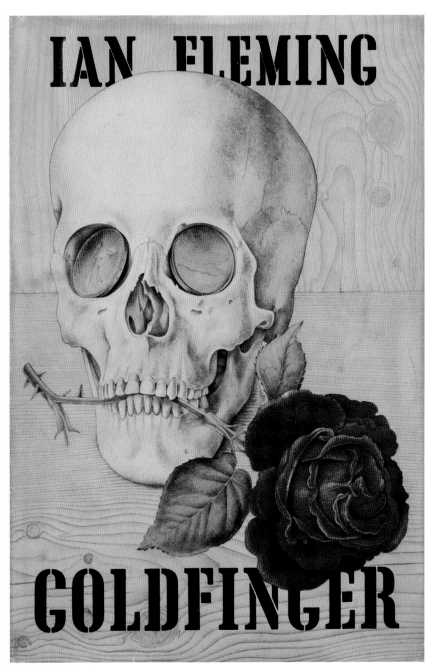

Above: *Goldfinger*, hardcover, Richard Chopping, Jonathan Cape, 1959
Right: *The Queen of Spades*, hardcover, Duggan, Doubleday Crime Club, 1944

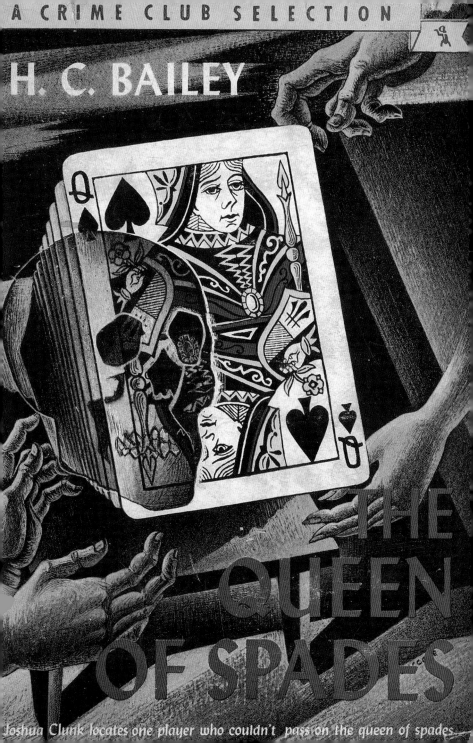

A CRIME CLUB SELECTION

H. C. BAILEY

THE QUEEN OF SPADES

Joshua Clunk locates one player who couldn't pass on the queen of spades

AND

DESIGN

FOR

DYING

Albert Jeffers

25

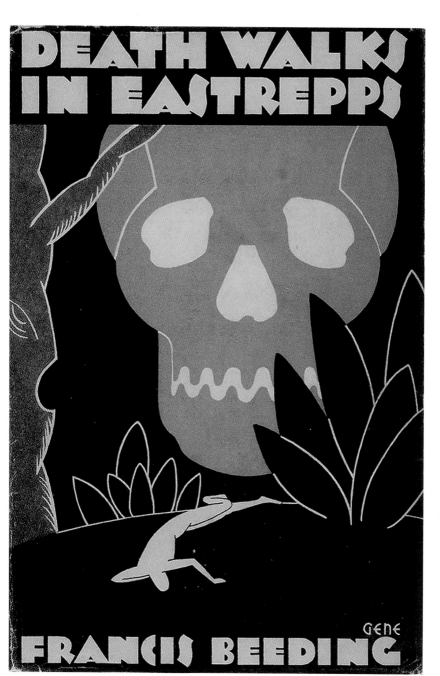

DEATH WALKS IN EASTREPPS

FRANCIS BEEDING

GENE

Left: *Design for Dying*, pulp digest, artist unknown, Parsee Publications, 1947
Above: *Death Walks in Eastrepps*, hardcover, Eugene Thurston, Mystery League, 1931

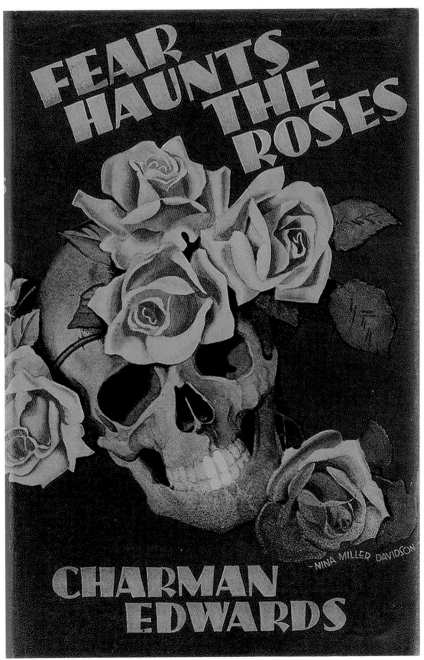

Above: *Fear Haunts the Roses*, hardcover, Nina Miller Davidson, Wars, Locke, & Co., 1936
Right: *Flynn's Detective Fiction*, pulp magazine, Rafael DeSoto, Popular Publications, 1944

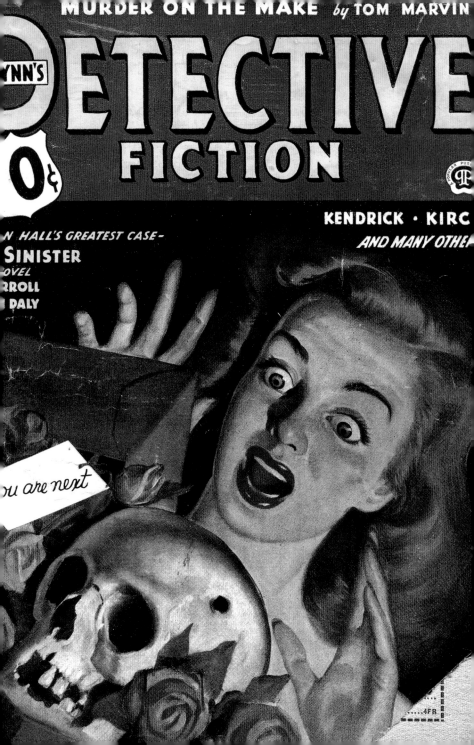

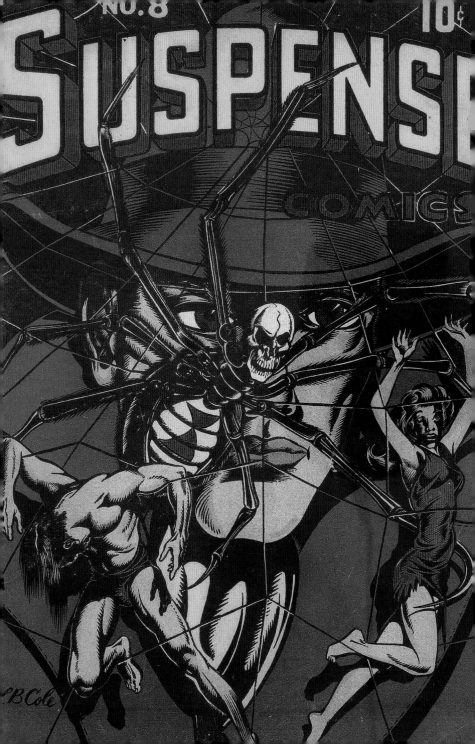

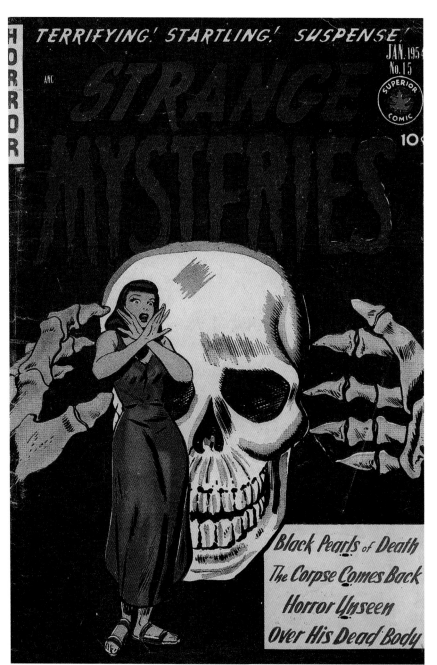

Left: *Suspense Comics* #8, comic book, L. B. Cole, Continental, 1945
Above: *Strange Mysteries* #15, comic book, artist unknown, Superior, 1954

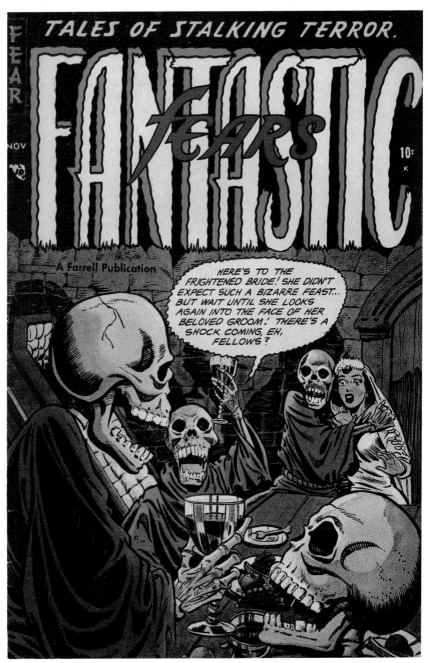

Above: *Fantastic Fears* #4, comic book, artist unknown, Farrell, 1953
Right: *Voodoo* #14, comic book, artist unknown, Farrell, 1954

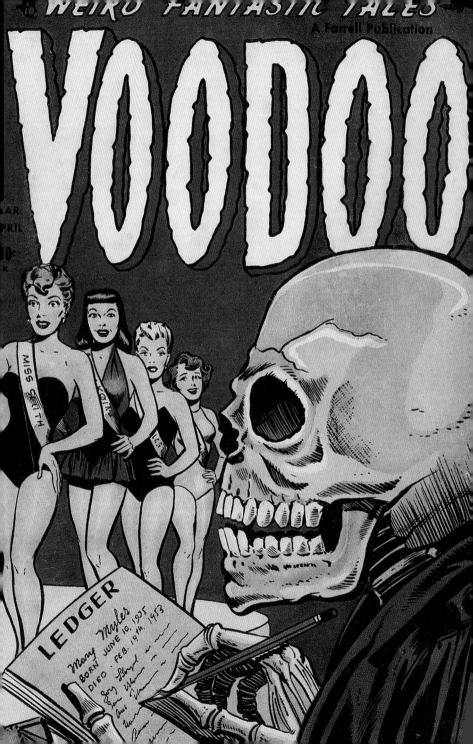

FDC

murder
out of mind

A FULL-LENGTH ORIGINAL NOVEL

KEN CROSSEN

FIVE STAR
MYSTERY 2

Above: *Murder Out of Mind*, pulp digest, artist unknown, Green Publishing Co., 1945

ANC

AN ORIGINAL

Crime is of the Essence

43 **FIVE STAR MYSTERY** 25c

A FULL-LENGTH ORIGINAL NOVEL
by JOE CSIDA

Above: *Crime Is of the Essence*, pulp digest, artist unknown, Green Publishing Co., 1946

MYSTERY
NOVELS
MAGAZINE

SPRING NUMBER

Complete Novels
256 Pages of
Detective Thrills

25c

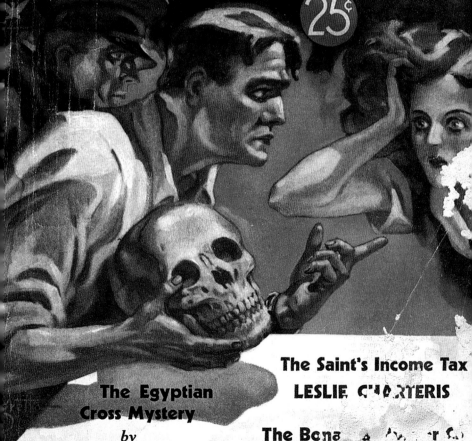

The Saint's Income Tax
LESLIE CHARTERIS

The Egyptian
Cross Mystery
by
ELLERY QUEEN

The Bona
CHARL

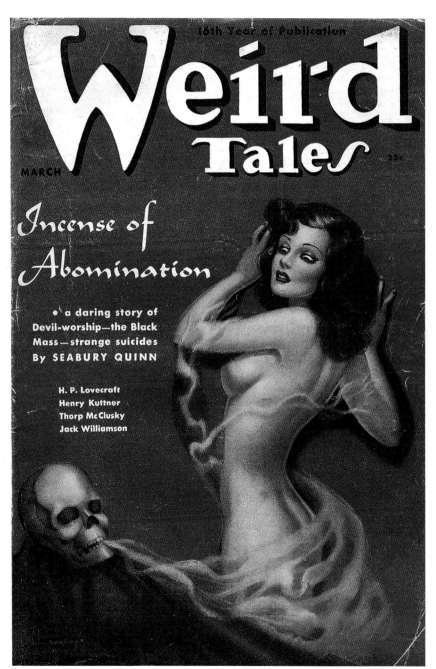

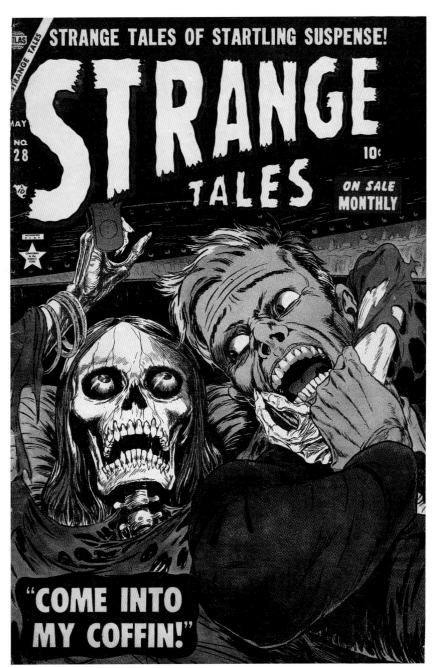

Above: *Strange Tales* #28, comic book, Harry Anderson, Atlas, 1954
Right: *New Detective*, pulp magazine, Rafael DeSoto, Popular Publications, 1948

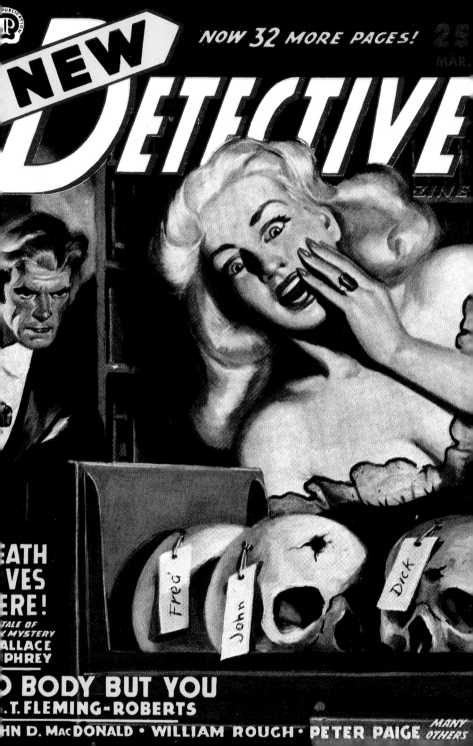

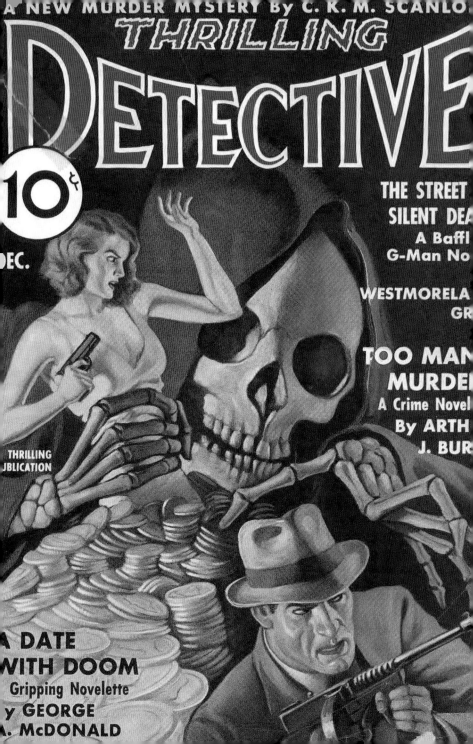

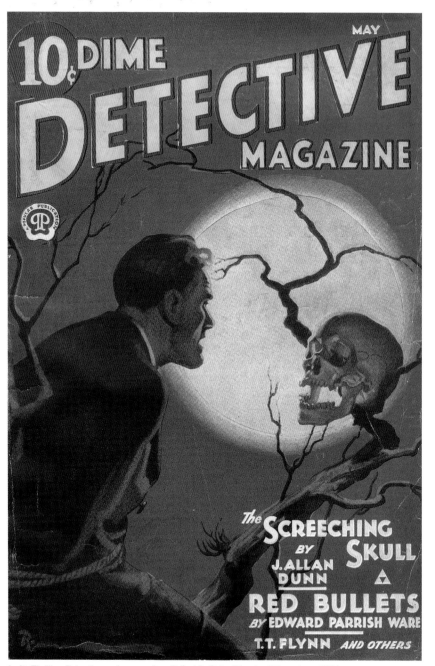

MAY

10¢ DIME
DETECTIVE
MAGAZINE

The SCREECHING
BY SKULL
J. ALLAN
DUNN ▲

RED BULLETS
BY EDWARD PARRISH WARE
T.T. FLYNN *AND OTHERS*

Left: *Thrilling Detective*, pulp magazine, Rafael DeSoto, Standard Magazines, 1937
Above: *Dime Detective Magazine*, pulp magazine, William Reusswig, Popular Publications, 1932　**109**

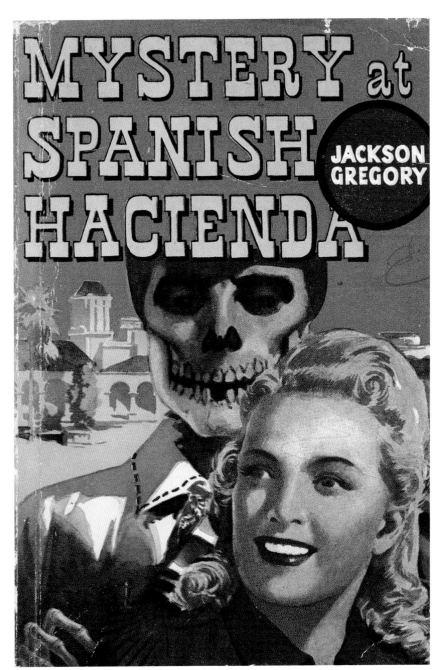

Above: *Mystery at Spanish Hacienda*, paperback, artist unknown, Avon, 1942
Right: *Wild West Weekly*, pulp magazine, H. W. Scott, Street & Smith, 1938

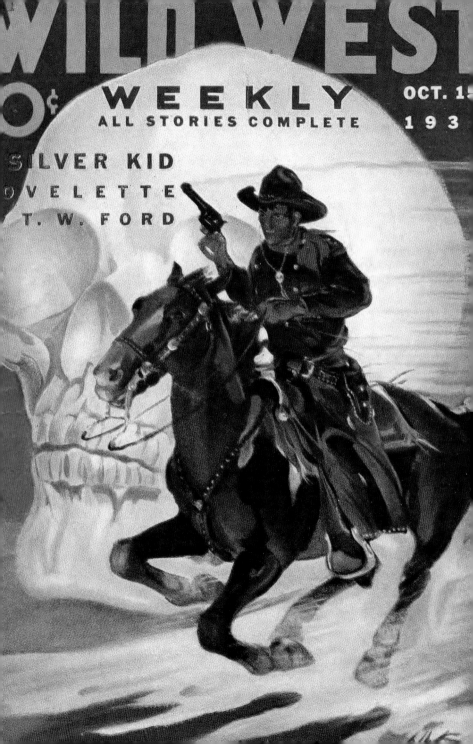

THE INVISIBLE HOST

HOST

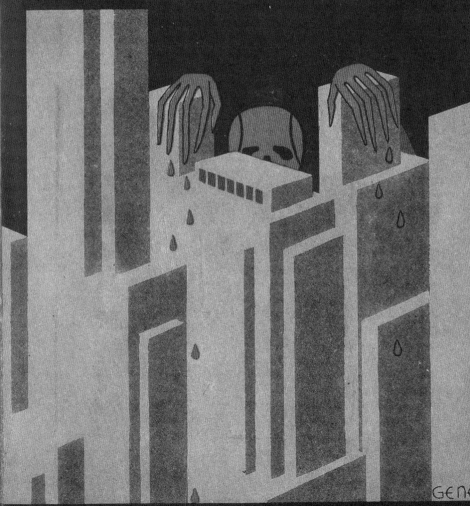

GENE

GWEN BRISTOW &
BRUCE MANNING

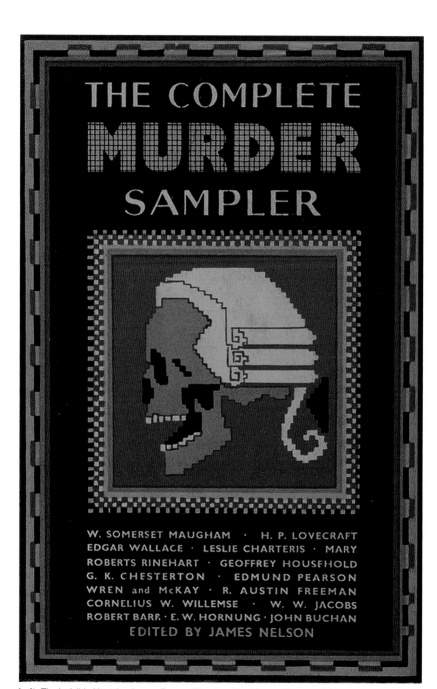

THE COMPLETE

MURDER

SAMPLER

W. SOMERSET MAUGHAM · H. P. LOVECRAFT
EDGAR WALLACE · LESLIE CHARTERIS · MARY
ROBERTS RINEHART · GEOFFREY HOUSEHOLD
G. K. CHESTERTON · EDMUND PEARSON
WREN and McKAY · R. AUSTIN FREEMAN
CORNELIUS W. WILLEMSE · W. W. JACOBS
ROBERT BARR · E. W. HORNUNG · JOHN BUCHAN
EDITED BY JAMES NELSON

Left: *The Invisible Host,* hardcover, Eugene Thurston, The Mystery League, 1930
Above: *The Complete Murder Sampler,* hardcover, artist unknown, London: MacDonald, 1950 **113**

Above: *The Skeleton in the Clock*, hardcover, Charles Lofgren, William & Morrow Co., 1948

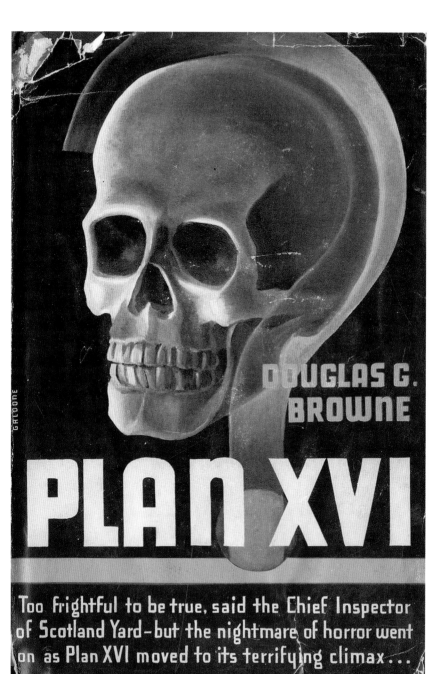

GREDONE

DOUGLAS G. BROWNE

PLAN XVI

Too frightful to be true, said the Chief Inspector of Scotland Yard—but the nightmare of horror went on as Plan XVI moved to its terrifying climax...

Above: *Plan XVI*, hardcover, artist unknown, Double Day Crime Club, 1934

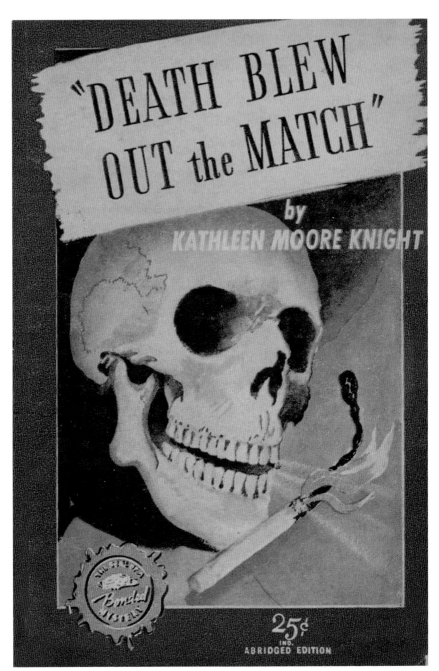

"DEATH BLEW OUT the MATCH"

by KATHLEEN MOORE KNIGHT

25¢
IND.
ABRIDGED EDITION

Above: *Death Blew Out the Match*, paperback, H. Lawrence Hoffman, Bonded Mystery, 1946
Right: *Argosy*, pulp magazine, Paul Stahr, Munsey, 1934

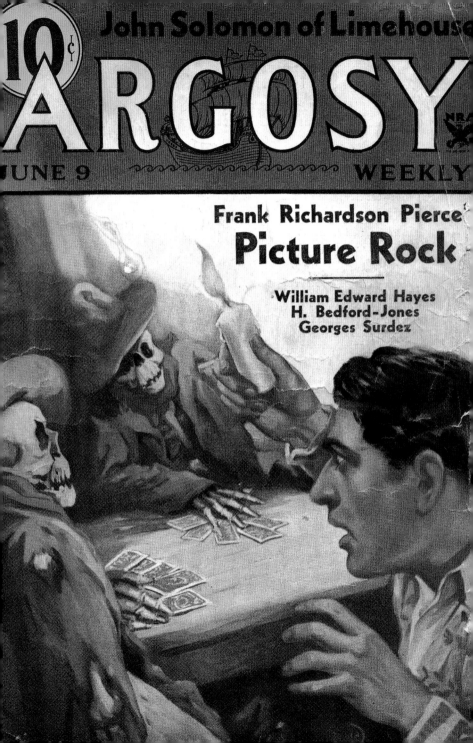

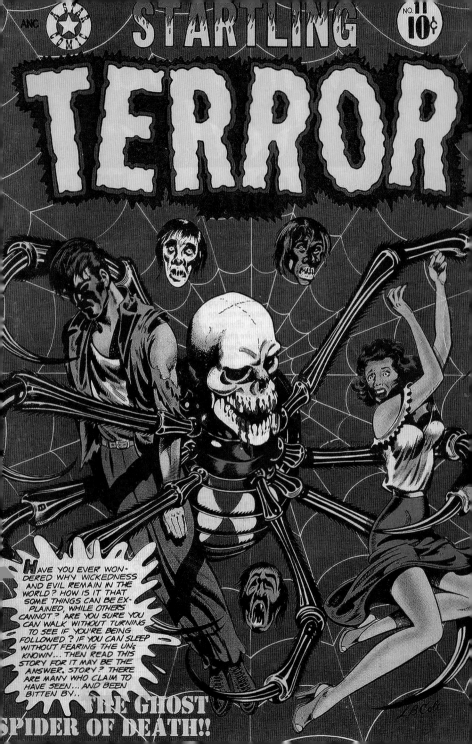

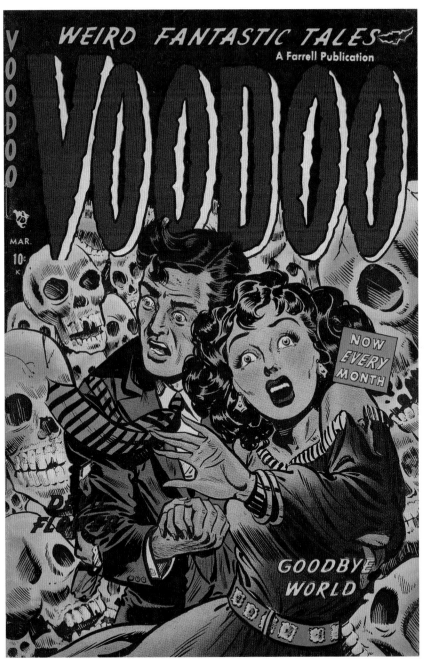

Left: *Startling Terror* #11, comic book, L. B. Cole, Star Publications, 1952
Above: *Voodoo* #7, comic book, artist unknown, Farrell, 1953

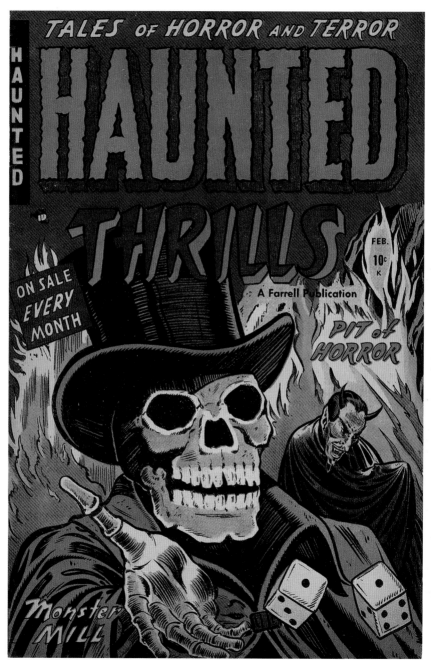

Above: *Haunted Thrills* #6, comic book, artist unknown, Farrell, 1953
Right: *Adventures into the Unknown* #33, comic book, Ken Bald, ACG, 1952

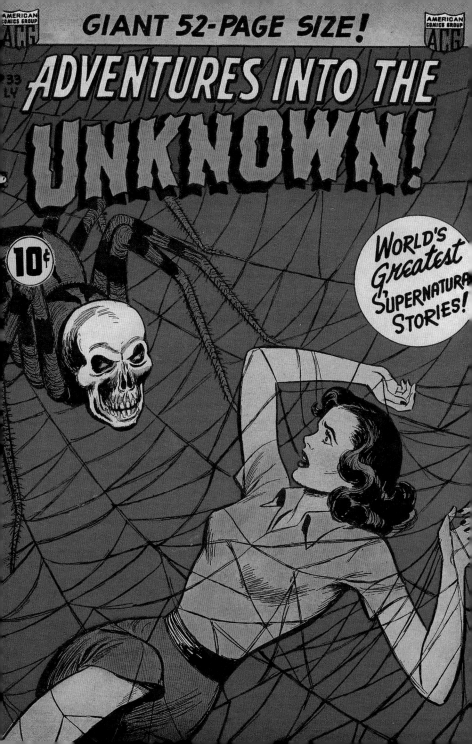

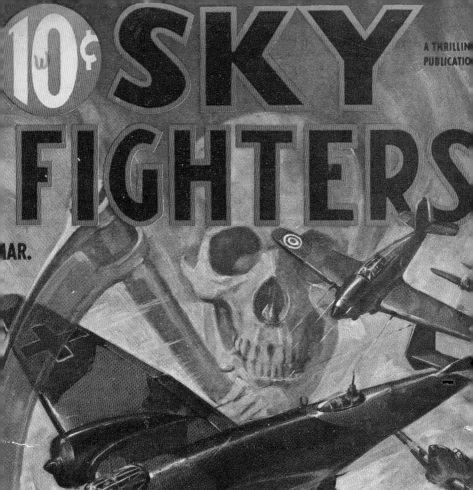

10¢

A THRILLING PUBLICATION

SKY FIGHTERS

MAR.

FEATURING

HELL OVER HELIGOLAND
A Novel of Today's War
By ARCH WHITEHOUSE

KILLER DILLER
A Novelet of a Sky Hellion
By F. E. RECHNITZER

ARMY AND NAVY SERI

99TH OBSERVATION SQUADRON
THE STORY BEHIN
THE INSIGNIA

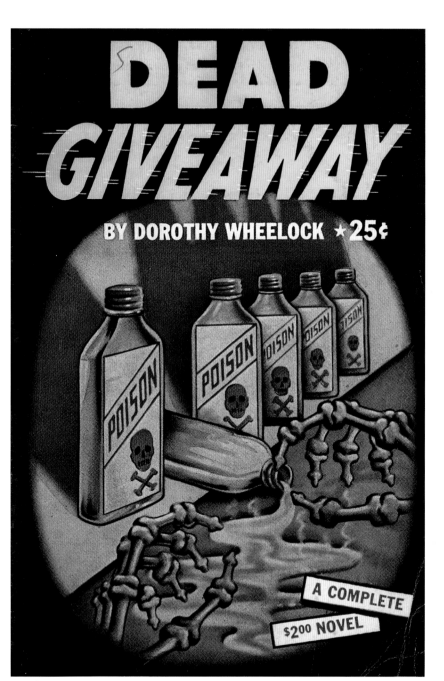

DEAD
GIVEAWAY

BY DOROTHY WHEELOCK ★ 25¢

A COMPLETE
$2⁰⁰ NOVEL

Left: *Sky Fighters*, pulp magazine, Rudolph Belarski, Standard Publications, 1940
Above: *Dead Giveaway*, pulp digest, Cardwell Higgins, Bard Publishing, 1944

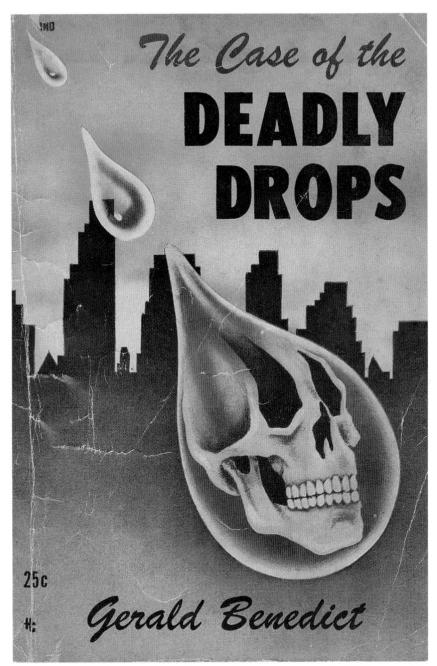

The Case of the
DEADLY
DROPS

25c

Gerald Benedict

Above: *The Case of the Deadly Drops*, pulp digest, artist unknown, The Edell Company, 1941
Right: *Midsummer Night's Murder*, pulp digest, Peter Driben, Select Publications, 1945

"A Murder Mystery"

MIDSUMMER NIGHT'S
MURDER

By Lee Crosby

5¢

DEC.

20c

DIME
MYSTERY
MAGAZIN

COMBINED WITH HORROR MYSTERY

HEAD
OF TH
CORPS
PARAD

by FRANC
K. ALLA

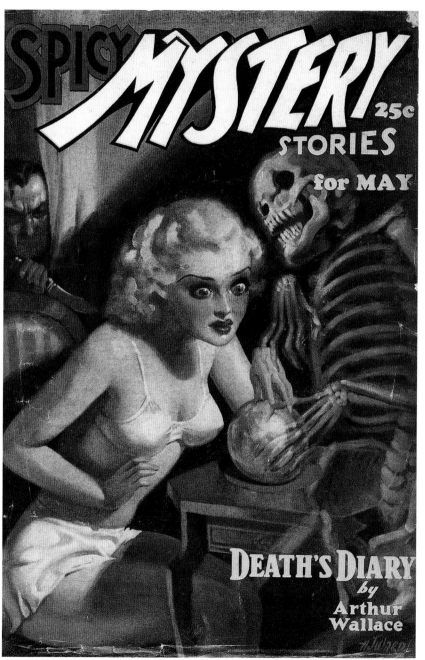

Left: *Dime Mystery Magazine*, pulp magazine, Albert Drake, Popular Publications, 1949
Above: *Spicy Mystery Stories*, pulp magazine, H. J. Ward, Culture, 1936

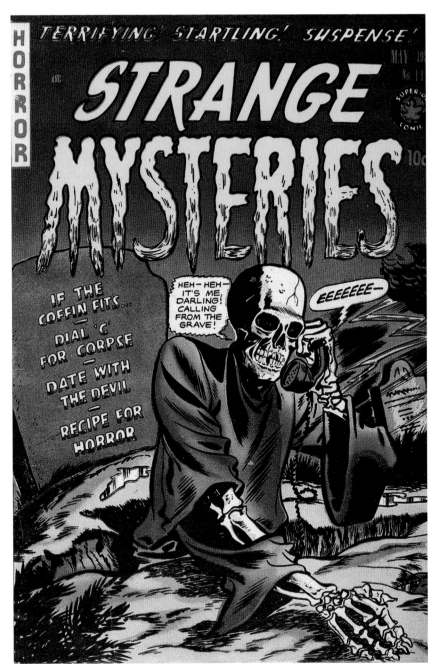

Above: *Strange Mysteries* #11, comic book, artist unknown, Superior, 1953
Right: *Thrilling Detective*, pulp magazine, Rudolph Belarski, Better Publications, 1948

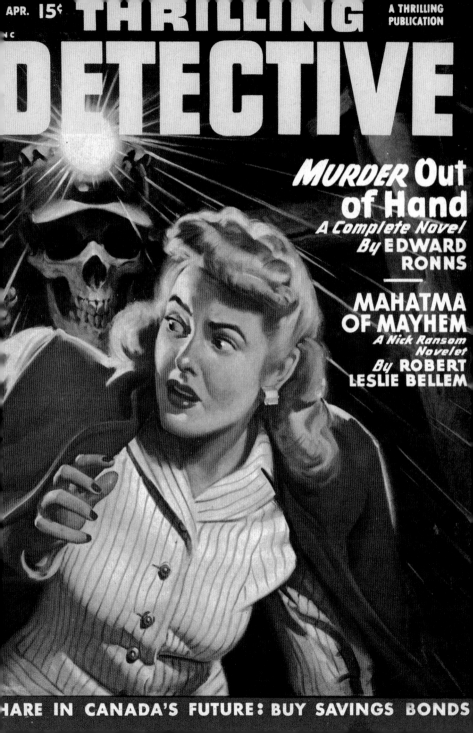

APR. 15¢

THRILLING

A THRILLING
PUBLICATION

DETECTIVE

MURDER Out of Hand
A Complete Novel
By EDWARD RONNS

MAHATMA OF MAYHEM
A Nick Ransom Novelet
By ROBERT LESLIE BELLEM

HARE IN CANADA'S FUTURE: BUY SAVINGS BONDS

THE SUBMARINE SIGNALED... MURDER!

BY ALLAN R. BOSWORTH

A COMPLETE 2.00 NOVEL

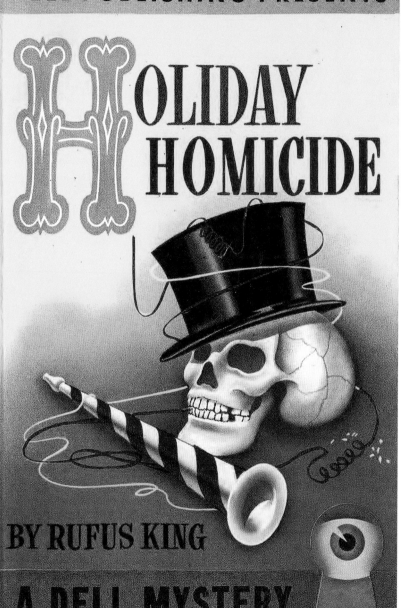

DELL PUBLISHING PRESENTS

HOLIDAY HOMICIDE

BY RUFUS KING

A DELL MYSTERY

Left: *The Submarine Signaled . . . Murder!*, pulp digest, artist unknown, Select Publications, 1942
Above: *Holiday Homicide*, paperback, Gerald Gregg, Dell Books, 1943 **131**

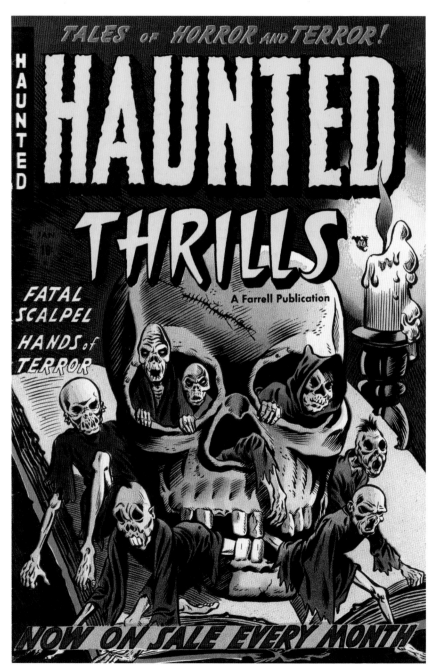

Above: *Haunted Thrills* #5, comic book, artist unknown, Farrell, 1953
Right: *Eerie Adventures* #1, comic book, Allen Anderson, Ziff-Davis, 1951

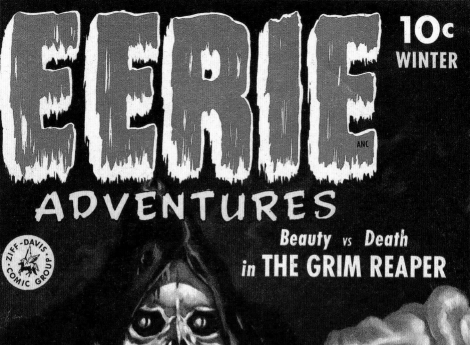

EERIE

ADVENTURES

10c
WINTER

ANC

ZIFF-DAVIS COMIC GROUP

Beauty vs Death
in THE GRIM REAPER

error in the
Everglades
AMPIRES
OF
VENUS

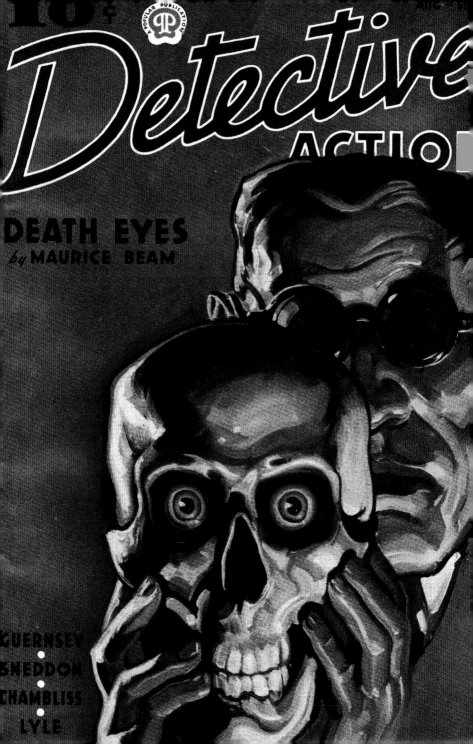

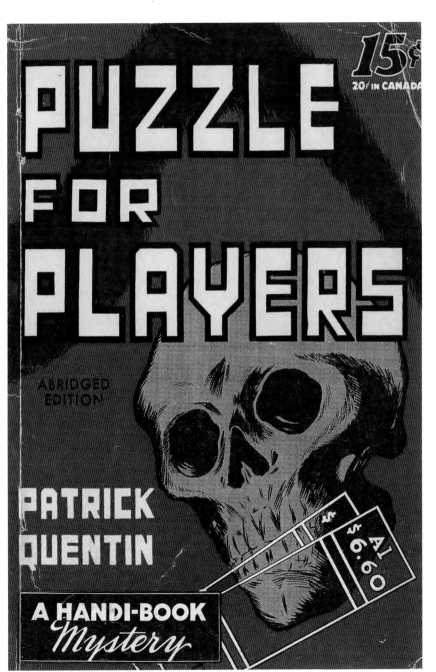

Left: *Detective Action*, pulp magazine, Charles DeFeo, Popular Publications, 1937
Above: *Puzzle for Players*, pulp digest, artist unknown, Quinn Publishing, 1946

A DELL BOOK

DELL 303

The **MIRABILIS DIAMOND**

JEROME ODLUM

WITH CRIME MAP ON BACK COVER

A DELL MYSTERY

Above: *The Mirabilis Diamond*, paperback, Gerald Gregg, Dell Books, 1949
Right: *Dime Mystery*, pulp magazine, Rafael DeSoto, Popular Publications, 1945

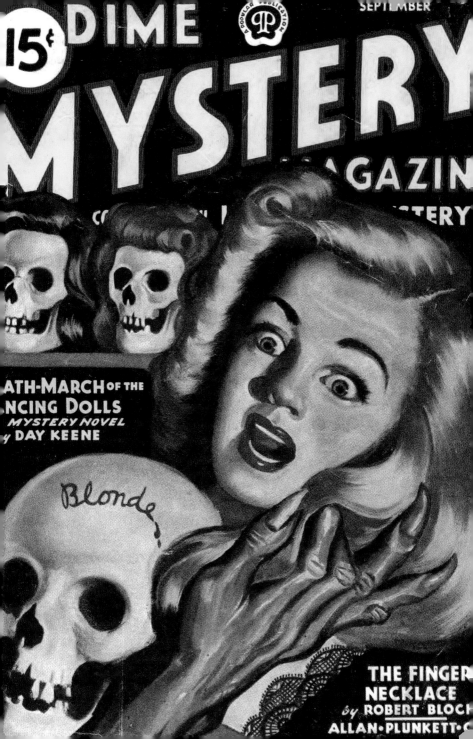

THRILLING

COMICS

10¢

NO. 1

DR. STRAN

FEATURING A COMPLETE
"DR. STRANGE" ACTION ADVENTURE

CASH PRIZES

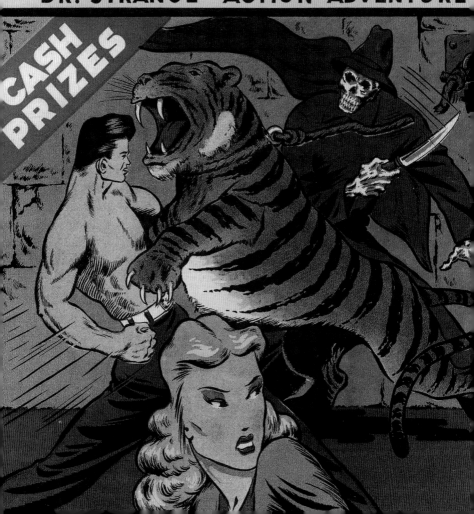

Left: *Thrilling Comics* #1, comic book, Better Publications, Alexander Kostuk, 1940
Above: *Amazing Stories*, pulp magazine, H. W. McCauley, Ziff-Davis, 1943

Above: *Chamber of Chills* #21, comic book, Lee Elias, Harvey, 1954

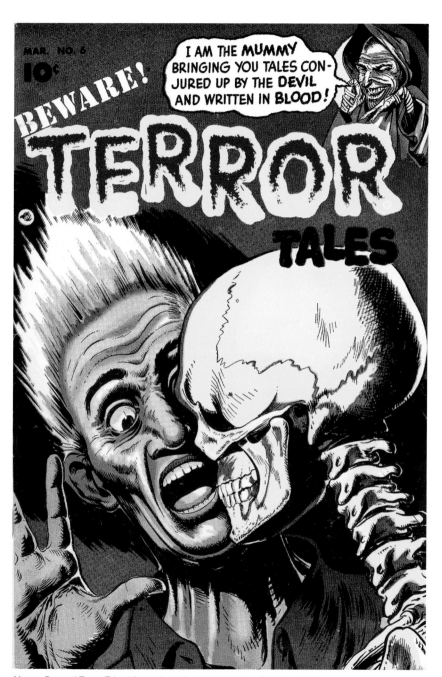

Above: *Beware! Terror Tales* #6, comic book, artist unknown, Fawcett, 1953

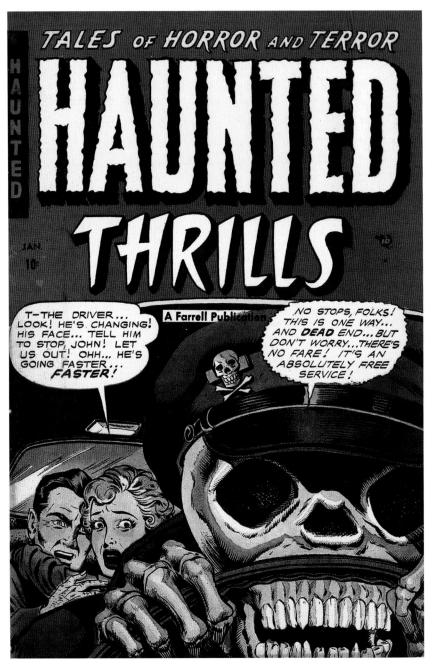

Above: *Haunted Thrills* #13, comic book, artist unknown, Farrell, 1954
Right: *Crack Detective Stories*, pulp magazine, Milton Luros, Double-Action, 1948

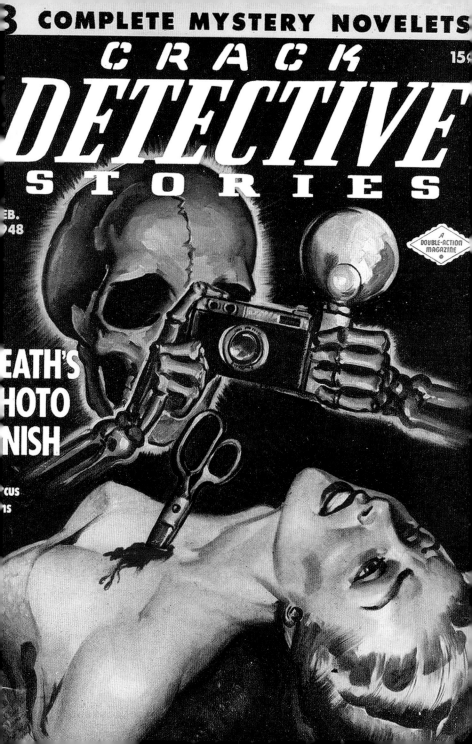

THE
VICE CZAR MURDERS

by
*Franklin
Charles*

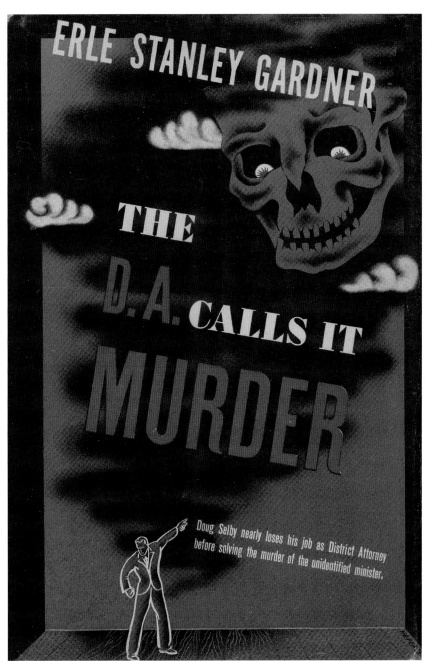

ERLE STANLEY GARDNER

THE
D.A. CALLS IT
MURDER

Doug Selby nearly loses his job as District Attorney before solving the murder of the unidentified minister.

Left: *The Vice Czar Murders*, pulp digest, artist unknown, R. W. Company, 1941
Above: *The D. A. Calls It Murder*, hardcover, artist unknown, Triangle Books, 1941

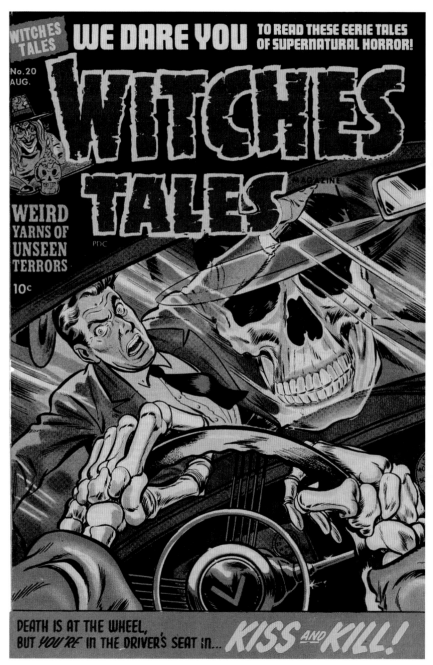

Above: *Witches Tales* #20, comic book, Lee Elias, Harvey, 1953
Right: *Design for Murder*, pulp digest, artist unknown, Novel Selections, 1942

Murder

WITH
LONG HAIR

By H. Donald Spatz

2

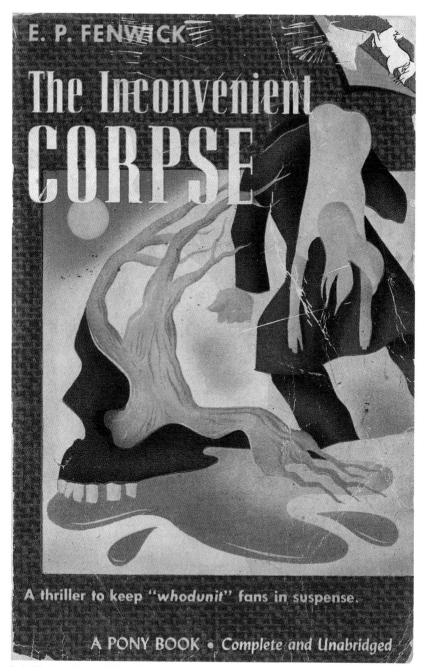

Left: *Murder with Long Hair*, pulp digest, Cardwell Higgins, Zenith Publishing, 1944
Above: *The Inconvenient Corpse*, paperback, H. Lawrence Hoffman, Pony Book, 1946 **149**

202

pb

THE
DUTCH SHOE
MYSTERY

ELLERY QUEEN

POCKET BOOK EDITION COMPLETE & UNABRIDGED

Above: *The Dutch Shoe Mystery*, paperback, George Mayers, Pocket Book, 1942
Right: *Murder on the Downbeat*, pulp digest, H. Lawrence Hoffman, Death House, 1944

MURDER on the DOWNBEAT

ROBERT AVERY

DEATH HOUSE MYSTERY

25¢

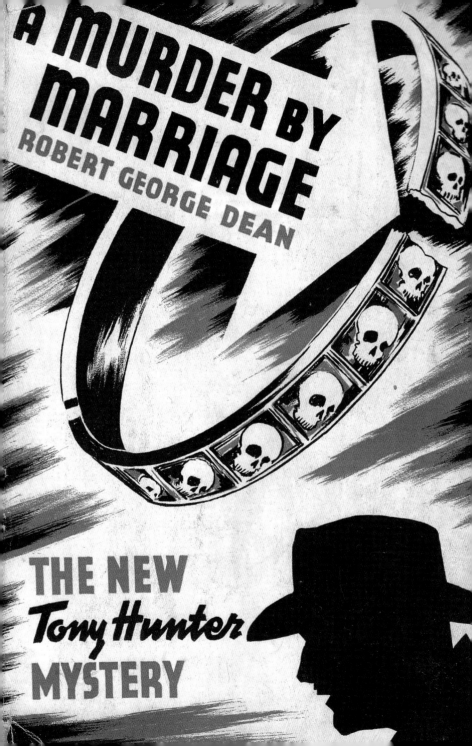

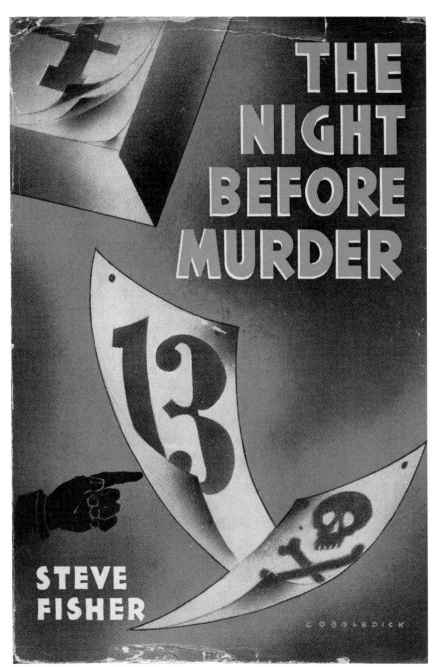

Left: *A Murder by Marriage*, hardcover, artist unknown, Charles Scribner's Sons, 1940
Above: *The Night Before Murder*, hardcover, Carl Cobbledick, Hillman-Curl, Inc., 1945 **153**

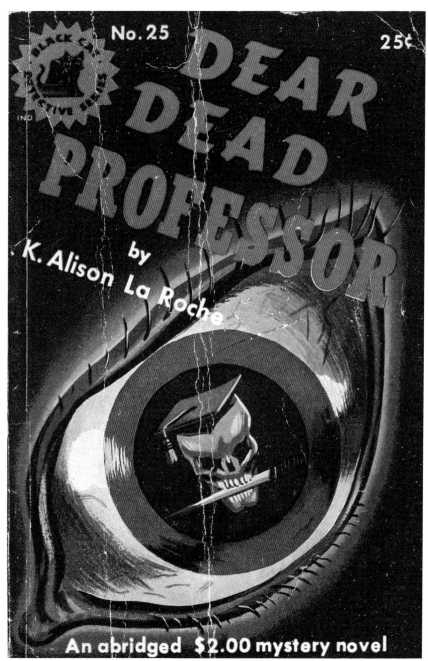

Above: *Dear Dead Professor*, pulp digest, artist unknown, Crestwood Publishing, 1946

Right: *The Thorne Theater Mystery*, pulp digest, artist unknown, Crestwood Publishing, 1946

the THORNE THEATER MYSTERY

An abridged $2:00 mystery novel by
JOSHUA WILLARD

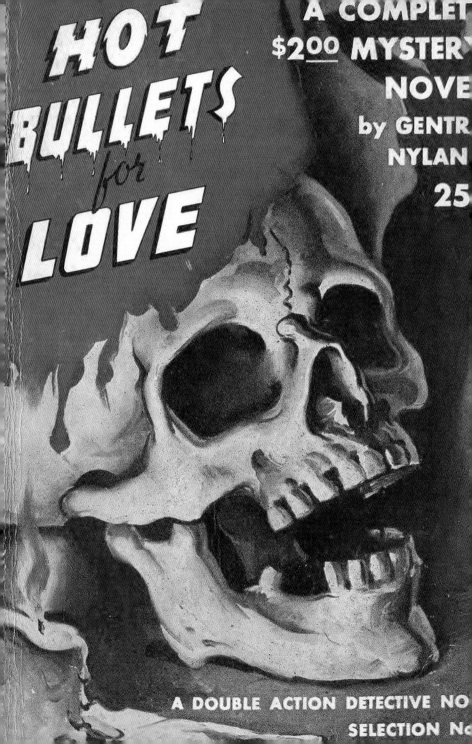

HOT BULLETS for LOVE

DEATH DEMANDS AN AUDIENCE

HELEN REILLY

POPULAR LIBRARY

Left: *Hot Bullets for Love*, pulp digest, artist unknown, Close-Up, Inc., 1943
Above: *Death Demands an Audience*, paperback, H. Lawrence Hoffman, Popular Library, 1943 **157**

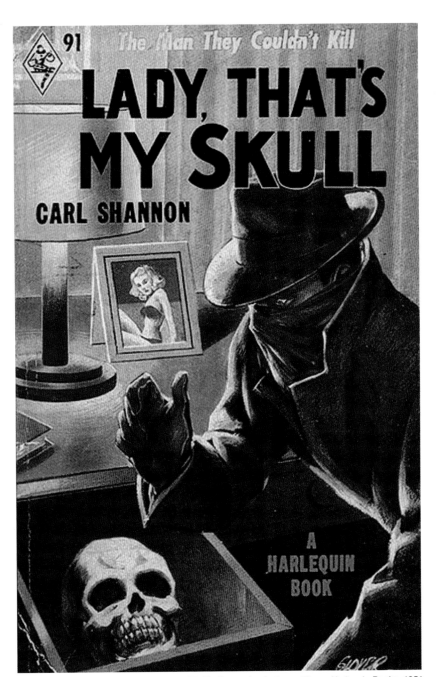

Above: *Lady, That's My Skull*, paperback, Amos Glover, Harlequin Books, 1951
Right: *Deep Lay the Dead*, pulp digest, artist unknown, Novel Selections, circa 1943

25
CENT
NO. 2

DEEP LAY THE DEAD

THE DEAD

BY

FREDERICK

C. DAVIS

Thriller Novel CLASSIC

FULL LENGTH NOVEL

STILLMAN PUBLICATION

L. M. C. No. 9

HAUNTED

HARBOR

by
DAYLE
DOUGLAS

EERIE
SERIES

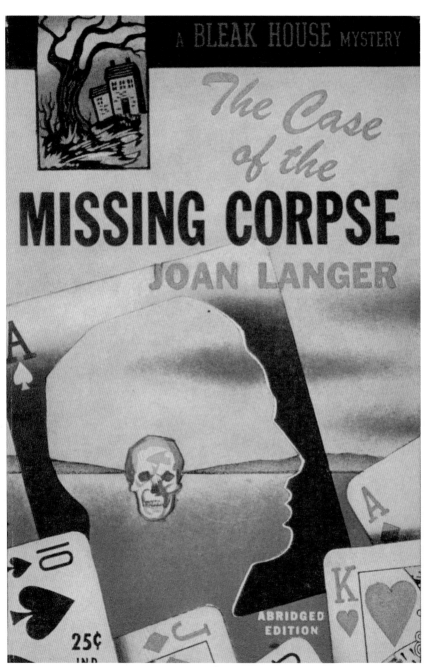

A BLEAK HOUSE MYSTERY

The Case of the

MISSING CORPSE

JOAN LANGER

ABRIDGED
EDITION

25¢

Left: *Haunted Harbor*, pulp digest, artist unknown, Metro Publications, 1945
Above: *The Case of the Missing Corpse*, paperback, artist unknown, Parsee Publications, 1946 **161**

THE
TRAVELING
CORPSES

A COMPLETE
2⁰⁰ NOVEL

BY
KURT STEEL

A CRIME NOVEL SELECTION ★ 25
No

Above: *The Traveling Corpses*, pulp digest, Peter Driben, Select Publications, 1942

DEATH

goes NATIVE

by max long

25¢

Above: *Death Goes Native*, pulp digest, artist unknown, Gem Publications, 1944

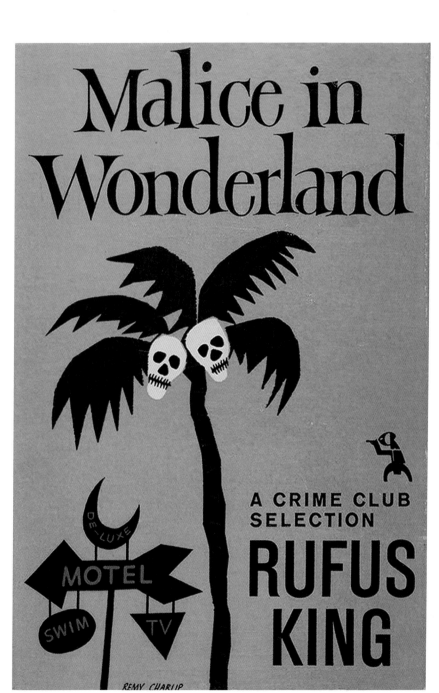

Malice in Wonderland

Wonderland

A CRIME CLUB
SELECTION

RUFUS
KING

REMY CHARLIP

Above: *Malice in Wonderland*, hardcover, Remy Charlip, Doubleday Crime Club, 1958
Right: *Wings Above the Claypan*, hardcover, artist unknown, Doubleday Crime Club, 1943

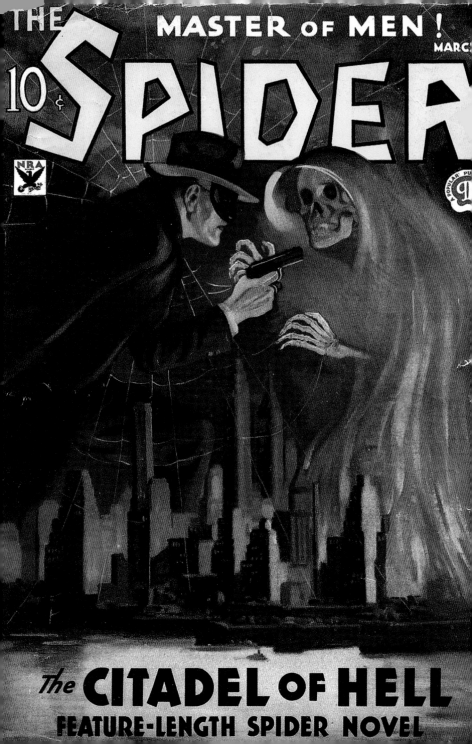

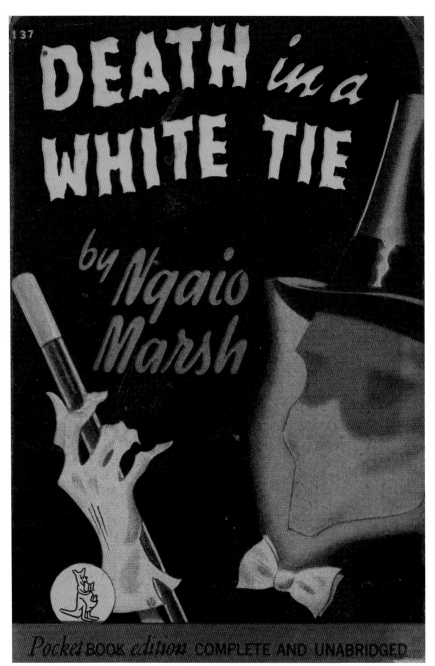

Left: *The Spider*, pulp magazine, John Howett, Popular Publications, 1934
Above: *Death in a White Tie*, paperback, artist unknown, Pocket Book, 1942

Erle Stanley Gardner

writing under the name of

A.A. Fair

Spill The Jackpot

A Donald Lam, Bertha Cool Mystery

Above: *Spill the Jackpot*, paperback, artist unknown, Dell Books, 1958
Right: *The Shadow Magazine*, pulp magazine, George Rozen, Street & Smith, 1933

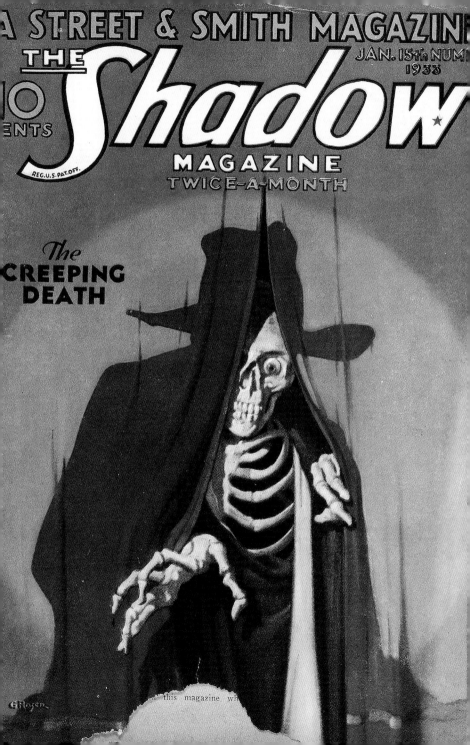

NOVEMBER

10¢

SECRET AGENT "X"

THE MAN OF A THOUSAND FAC[ES]

SERVANT
OF THE
SKULL
Complete Nove[l]
Great
Secret Agen[t]
Thriller

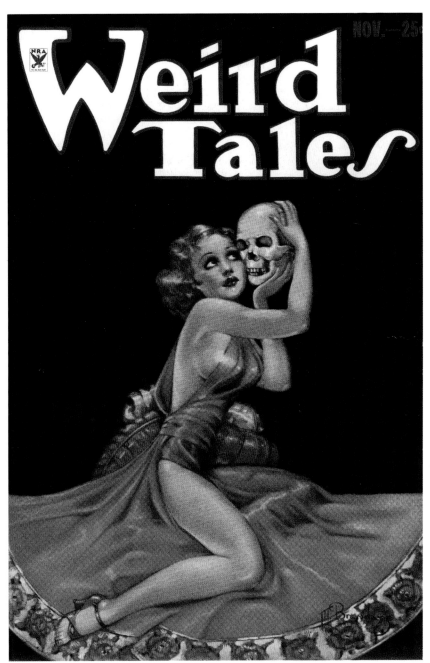

NOV.—25¢

Above: *Weird Tales*, pulp magazine, Margaret Brundage, Popular Fiction, 1933
Right: *Thrilling Mystery*, pulp magazine, Rudolph Belarski, Standard, 1944

FALL ISSUE

THRILLING
MYSTERY

LLING
ATION

MONARCHS OF
Murder
An Exciting Mystery Novel
By C. K. M. SCANLON

T ACTION

ECTIVE STORIES

DEATH IS A VAMPIRE
A Gripping Novelet

FOG
ON THE
MOUNTAIN

FREDERICA de LAGUNA

Author of THE ARROW POINTS TO MURDER.

CHRISTOPHER HALE

DEAD OF WINTER

Nature and a ruthless murderer add up to a violent death.

H·A·PEACE

Left: *Fog on the Mountain*, hardcover, Duggan, Doubleday Crime Club, 1938
Above: *Dead of Winter*, hardcover, artist unknown, Doubleday Crime Club, 1941